HISTORIC PHOTOS OF
WILMINGTON

TEXT AND CAPTIONS BY WADE G. DUDLEY

TURNER
PUBLISHING COMPANY

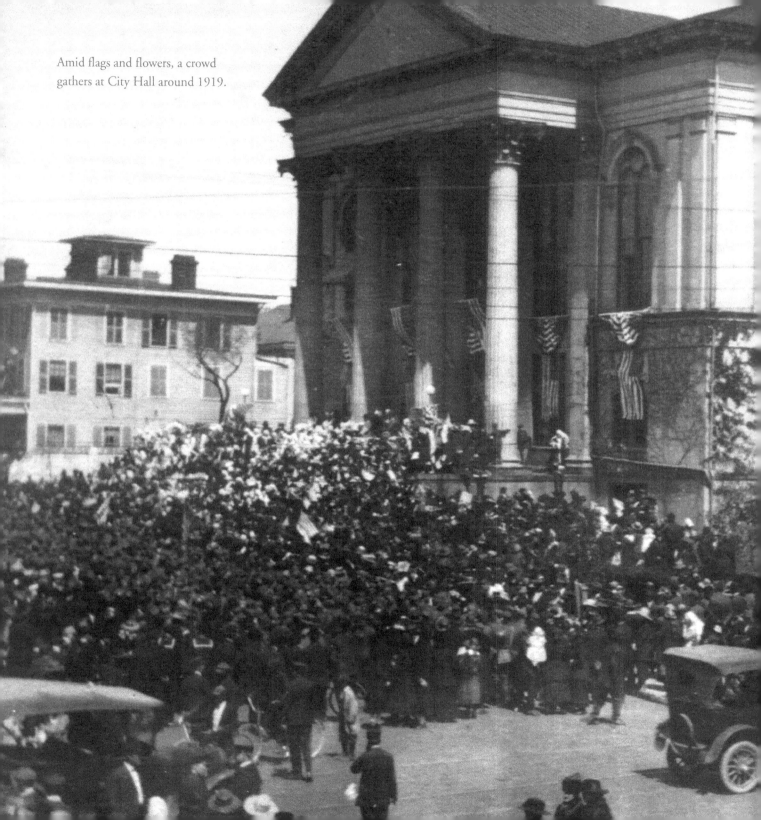

Amid flags and flowers, a crowd
gathers at City Hall around 1919.

HISTORIC PHOTOS OF
WILMINGTON

Turner Publishing Company
4507 Charlotte Avenue • Suite 100
Nashville, Tennessee 37209
(615) 255-2665

www.turnerpublishing.com

Historic Photos of Wilmington

Library of Congress Control Number: 2008901711

ISBN-13: 978-1-59652-442-2

ISBN-13: 978-1-68442-018-6 (hc)

Printed in the United States of America

08 09 10 11 12 13 14 15—0 9 8 7 6 5 4 3 2 1

CONTENTS

ACKNOWLEDGMENTS...VII

PREFACE...VIII

FROM CIVIL WAR TO SPANISH-AMERICAN WAR
 (1860–1899) ...1

A NEW CENTURY AND NEW BEGINNINGS
 (1900–1916) ...43

FROM GREAT WAR TO GREAT DEPRESSION
 (1917–1929) ..125

FOUR DECADES OF CHANGE
 (1930–1970)...181

NOTES ON THE PHOTOGRAPHS201

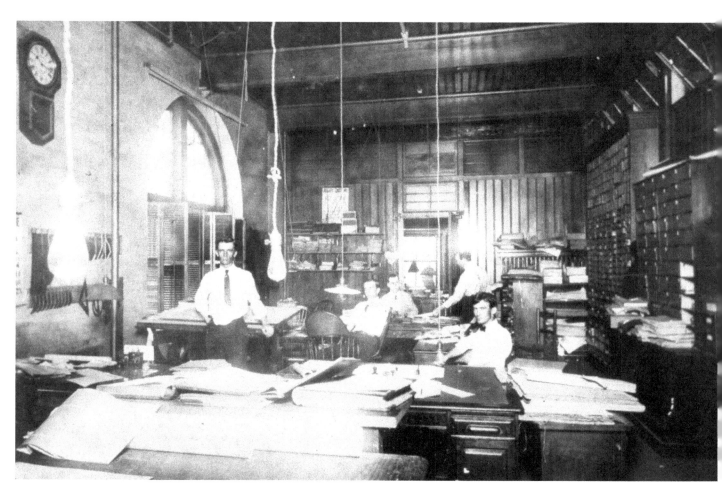

The offices of the Atlantic Coast Line railroad were a busy place in 1906. Thank heaven for the utilitarian electric lights that permitted the offices to run just like the trains: around the clock.

ACKNOWLEDGMENTS

This volume, *Historic Photos of Wilmington,* is the result of the cooperation and efforts of many individuals and organizations. It is with great thanks that we acknowledge the valuable contribution of the following for their generous support:

The New Hanover Public Library
Cape Fear Historical Society
Amon Carter Museum, Fort Worth, Texas

Thanks as well to the (always helpful) staff of the Verona Joyner Langford North Carolina Collection at East Carolina University.

PREFACE

The oldest land grant remaining that relates to a settlement on the east bank of the Northeast Cape Fear River dates to 1733, though Englishmen probably lived there some years earlier. The area had several names: New Liverpool, New Town, and Newton. However, when the Assembly of North Carolina incorporated the village as a town and township in 1739, Governor Gabriel Johnson insisted that it be named Wilmington in honor of his patron, Spencer Compton, earl of Wilmington.

As settlements expanded along the upper Cape Fear River system, colonial Wilmington gained importance as the only deepwater port in North Carolina. Cotton, tobacco, and naval stores (tar, pitch, rosin, and turpentine) floated downstream to join rice and indigo in its warehouses. Loaded on coasters or oceangoing vessels, these raw materials provided credit for manufactured goods from English merchants. Despite commercial success, Wilmington led North Carolina's resistance against taxation, including armed resistance to the Stamp Act in 1765. Joining in revolution, local citizens paid a steep price when the Royal Navy captured the town. British troops used Wilmington as a base in the latter stages of the war.

After securing freedom in 1783, the port of Wilmington grew even richer. Completion of the Wilmington and Weldon Railroad in 1840, linking the port to the interior of the Carolinas and Virginia, made the city an important hub on the East Coast. In 1861, when its citizens rose in a second (attempted) revolution, Wilmington became one of the most important cities in the South. By 1864, with the loss or close blockade of its sister ports, Southerners knew Wilmington as the terminus of the "Lifeline of the Confederacy," where blockade runners poured cargo and money for General Lee's Army of Virginia. Wilmington prospered—until the forts guarding it fell in 1865.

As a port and a railroad terminus (eventually, five railroads would have terminals in the city), Wilmington recovered quickly. It became known as a Republican stronghold and a city where former slaves and freemen could prosper. In 1898, any hope of equality for African Americans ended in an overthrow of the local Republican government. This marked the beginning of Jim Crow and strict segregation in Wilmington that would not truly end until well after 1970.

Wilmington is known as the "Port City" for good reason. Through two World Wars, its citizens gave strong support to the United States whether in service, shipments, or shipbuilding. That such activities brought prosperity, frequently reflected in magnificent homes and public buildings across the years, remains secondary to the patriotism of Wilmington's citizens.

Photographs from as early as 1860 reveal that any narrative about Wilmington, located on a relatively thin strip of land between the Cape Fear River and the Atlantic Ocean, must necessarily be somewhat of a watery tale: a story of beaches, sounds, inlets, shoals, river, boats, ships, ferries, and docks. As such, much of this excursion is regional in nature, reaching across sounds and river by railway, tramway, and boats to local beaches—especially Wrightsville Beach. The tourism that resulted from its favorable location is just as important to the story of Wilmington as any business within its city limits.

This book is a history, of sorts, but a history told primarily with photographs: seconds in time captured by the flash of a camera. I have made no attempt to be thematic, though I certainly think themes emerge. And I make no claim that this is a "complete" history. It is not. However, I do think it captures much of the spirit of the grand old Port City of North Carolina, and of the fun-loving, hard-working, sun-worshiping souls who have had the luck to reside therein.

With the exception of cropping images where needed and touching up imperfections that have accrued over time, no other changes have been made. The caliber and clarity of many photographs are limited by the technology of the day and the ability of the photographer at the time they were made.

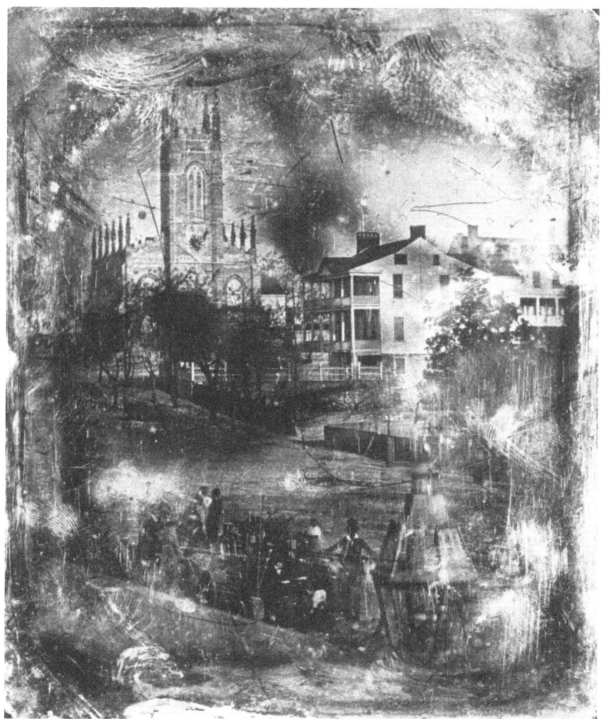

The earliest surviving photograph of Wilmington dates to 1847. St. James Church towers over the Burgwin-Wright House, as viewed from the waterfront.

From Civil War to Spanish-American War

(1860–1899)

By the coming of war with the northern states, Wilmington prospered as North Carolina's only deep-water port. The steam engine, whether powering steamboats plying river and sound or the engines of the Wilmington & Weldon Railroad, coupled with state efforts to improve river navigation, brought more produce and naval stores to Wilmington than at any time in its past.

The war may have stripped Wilmington of able-bodied men, but its port facilities boomed. Difficult to blockade owing to shoals and shallow inlets and protected by forts (especially Fort Fisher), gun batteries, and locally built ironclads, Wilmington remained a haven for blockade runners until the last months of the war. Linked to Virginia and points south by the Wilmington & Weldon line, the Port City became known as the terminus of the "Lifeline of the Confederacy."

The end of the war brought changes, especially when an entrenched Republican local government successfully supported racial equality. Between 1865 and 1898, Wilmington became a showplace for racial progress, drawing an influx of former slaves and northern-educated African Americans. The Wilmington Race Riot of 1898 ousted the Republican Party from power, shed the blood of the Port City's black citizens, and restored the city to its antebellum order, thus opening the door to Jim Crow laws and strict segregation.

If the late 1800s brought regression in racial equality, they opened the door to positive changes in other areas. The first telephone appeared in Wilmington in 1878. Electricity reached the region in 1886, and utility poles sprouted along city streets (most cobbled by the end of the decade) in ever-increasing numbers thereafter. Business boomed, supporting new mercantile buildings, homes, churches, schools, electric streetcars, and even a yacht club. A new railroad linked the wealthy citizens of Wilmington with their summer homes at Wrightsville Beach, while excursion boats traveled from the Port City to Southport and points in between, especially the popular resort developing at Carolina Beach.

Prosperity seemed to be everywhere, yet nature had a way of reminding those who called Wilmington home that prosperity could end. In February 1899, a sudden snowstorm closed the city with a foot of snow. The rains came heavy that summer, washing away roads. Then, in November, a late season hurricane ripped through the area. With much rebuilding ahead, the nineteenth century in the Port City ended.

The massive earthworks of Fort Fisher guarded Wilmington through most of the Civil War. After repelling a Union amphibious armada in December 1864, the largest earthen fortification in the world at that time surrendered to a well-organized attack the following month. In this photograph, taken after its capture, a lonely Union sentinel stands guard over wreckage and munitions. Today, a superb state park preserves numerous historical artifacts at the site.

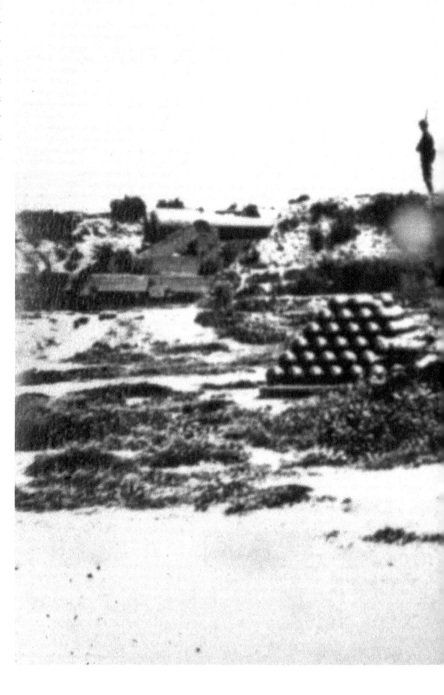

3

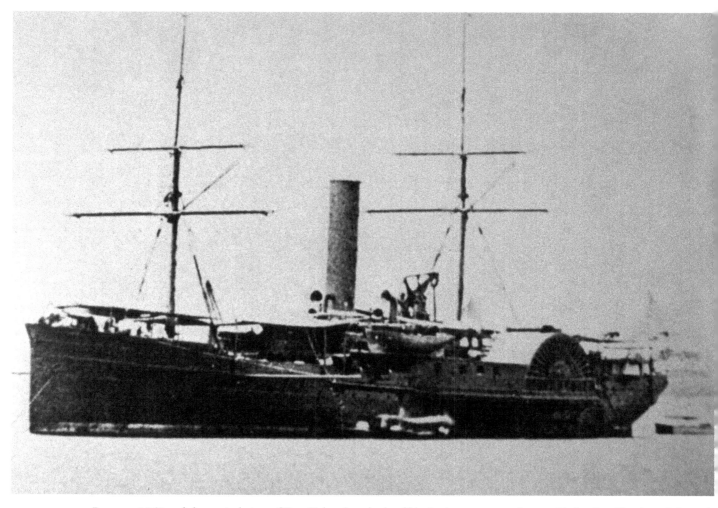

Between 1861 and the capitulation of Fort Fisher, hundreds of blockade runners sped across Frying Pan Shoals and through New or Old Inlet to unload munitions, uniforms, weapons, medicine, and a few luxury goods in Wilmington. There, laborers loaded the war matériel onto cars of the Wilmington & Weldon Railroad. The supplies rolling along this "Lifeline of the Confederacy" sustained Robert E. Lee's army until 1865.

The completion of the Wilmington & Weldon Railroad in 1840 (Wilmington & Raleigh Railroad until renamed in 1855) provided Wilmington with a link to regions beyond the watershed of the Cape Fear River. Because the W&W remained functional through most of the Civil War, it earned the nickname (along with its Wilmington terminus) of "Lifeline of the Confederacy."

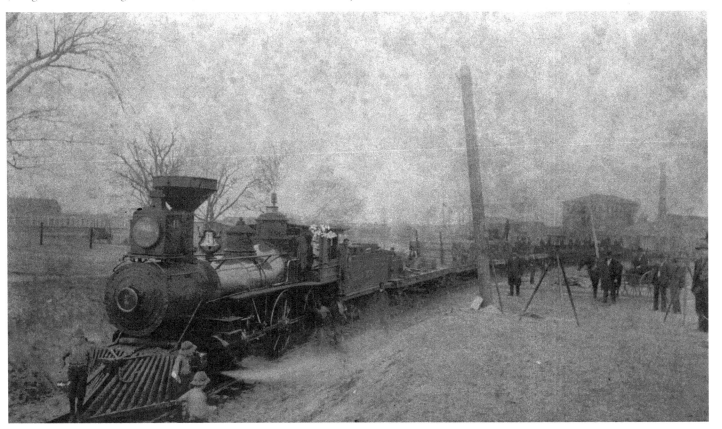

This 150-pounder Armstrong gun defended the seaward approaches to Fort Fisher until its capture. After the war, the Union relocated it to the U.S. Military Academy at West Point as a trophy gun.

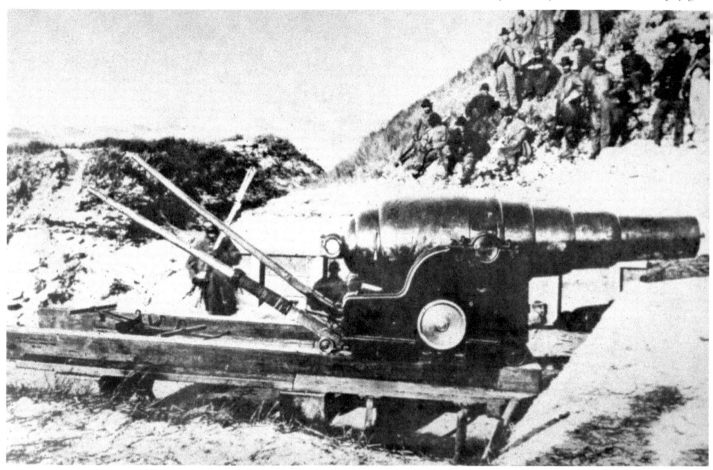

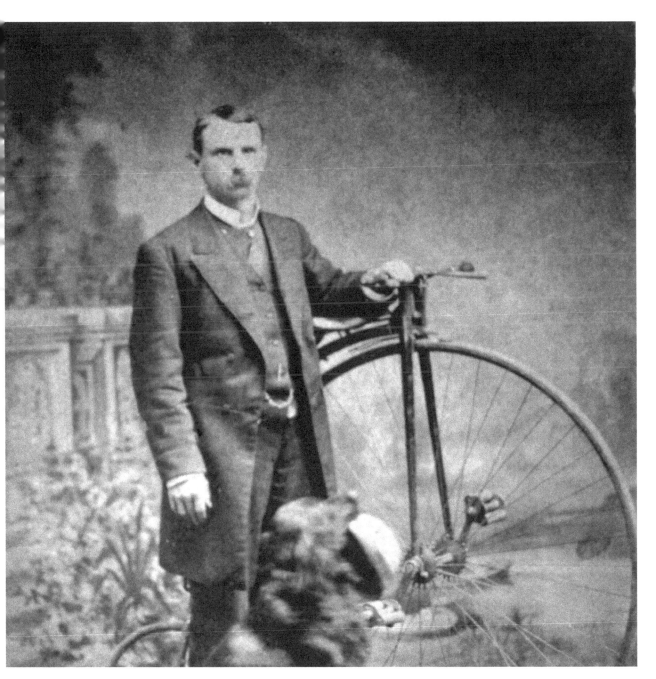

The penny-farthing, the first all-metal "high wheel" bicycle, appeared in 1870, at that time costing the average person an amount equal to about six months of wages. Fred Hamme, Sr., poses here in 1873 with his model—a status symbol even in the largest city in North Carolina (Wilmington was the only city with more than 10,000 residents in 1870). In later years, the price of the penny-farthing dropped.

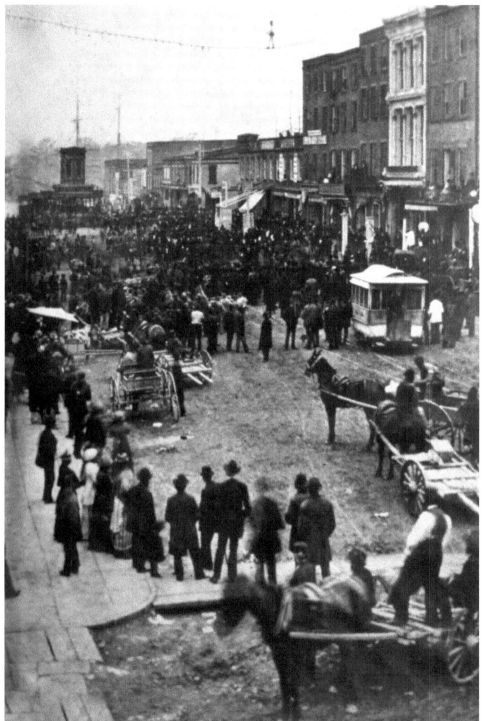

Is the circus in town? Traffic stops to watch a high-wire performer at Second and Market streets around 1880. Not pictured is the mysterious tunnel system, known as Jacob's Run, beneath their feet. Legends abound about the bricked-over old stream: smuggling, escaped prisoners, hidden slaves—work crews even discovered a fishing skiff while repairing the street in 1907. City Market is visible at the far end of the unpaved street.

An 1880 view from the waterfront south along the Cape Fear River captures the beauty and tranquillity of life in this old port city. Despite the introduction of steamers decades earlier, the cost-effectiveness of wind power kept sailing-ship freighters afloat until well after 1900, especially vessels hauling guano from Chile.

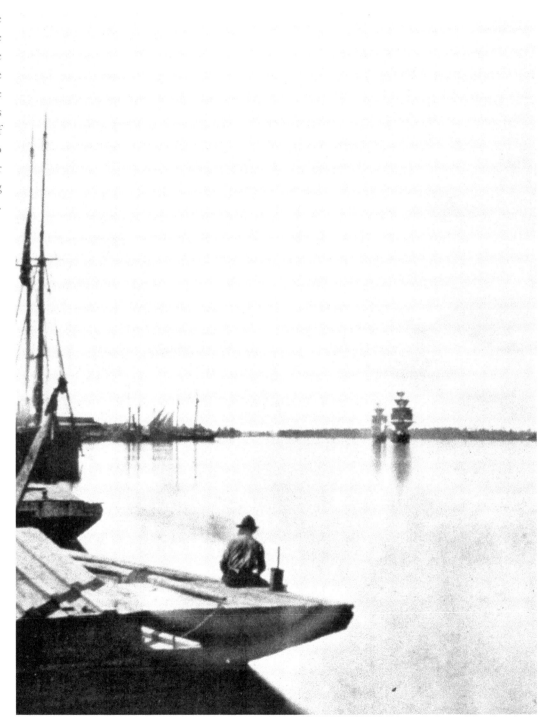

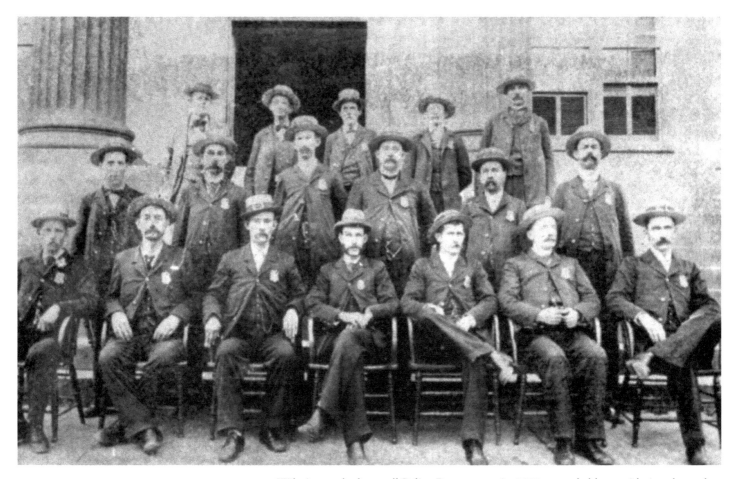

Wilmington had a small Police Department in 1880, remarkable considering the ruckus that merchant sailors in port could—and did—cause. Founded in 1739, locals called the police force "The Watch."

The original open-air City Market stood at the corner of Market and Water streets (thus the name Market Street). In 1881, this new City Market House on South Front Street between Dock and Orange streets replaced it.

To meet the needs of local residents, City Hospital opened at Tenth and Red Cross streets in 1881. James Walker Memorial Hospital replaced the aging structure at this site in 1901, continuing to serve the community into the 1960s.

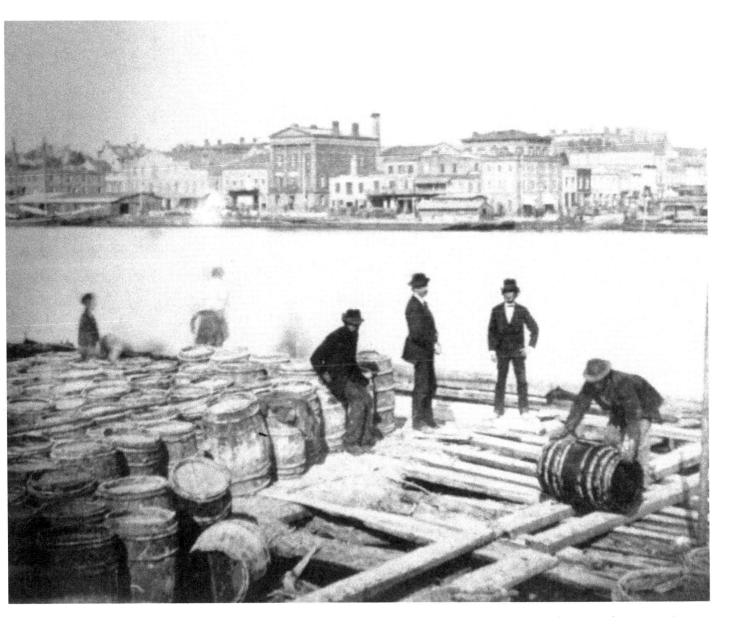

Workers handle barrels of turpentine on Eagle Island around 1890. Naval stores such as turpentine, tar, and rosin had shipped from Wilmington since its founding. Behind the men spreads the waterfront of Wilmington. In the center is the three-story Customs House, built in 1843 and demolished in 1915. A ferry operated from the base of Market Street until the 1920s, when bridges finally crossed the river.

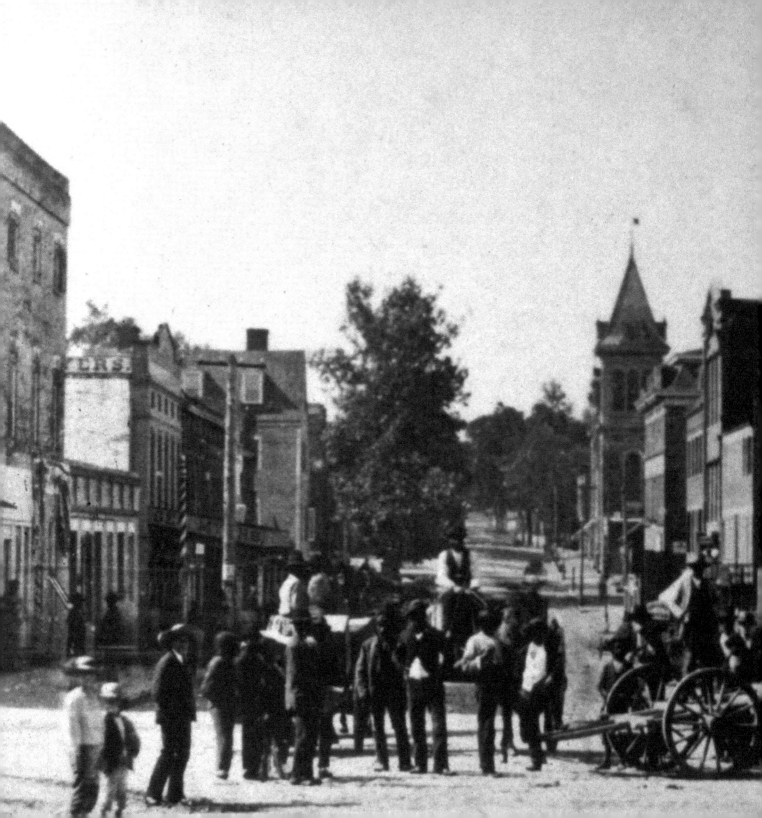

A crowd has gathered at Front and Market streets sometime in the 1880s. This view is south along Front Street.

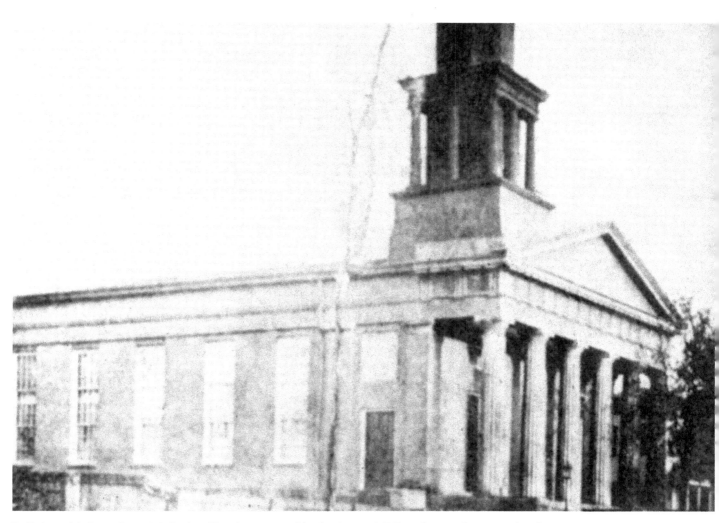

Built in 1844, Front Street Methodist Church was gutted by fire in 1886. When the members completed a new building on Mulberry Street the following year, the congregation took the name of Grace Methodist Church.

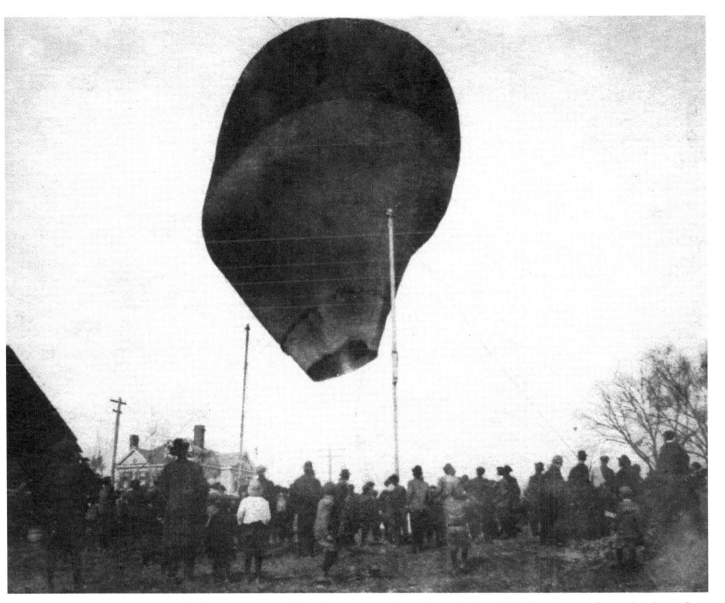

A gas balloon, precursor of dirigibles that would sail above the North Carolina coast in future decades, inflates in a field outside Wilmington in 1890. Passengers—if any brave souls were willing—would get one of the first bird's-eye views of the region.

Cotton is compacted, baled, weighed, and loaded onto the waiting bark from the Compress Dock in 1890. Despite steadily falling prices after 1870, cotton remained a staple of the region and one of the most important commodities shipped from Wilmington.

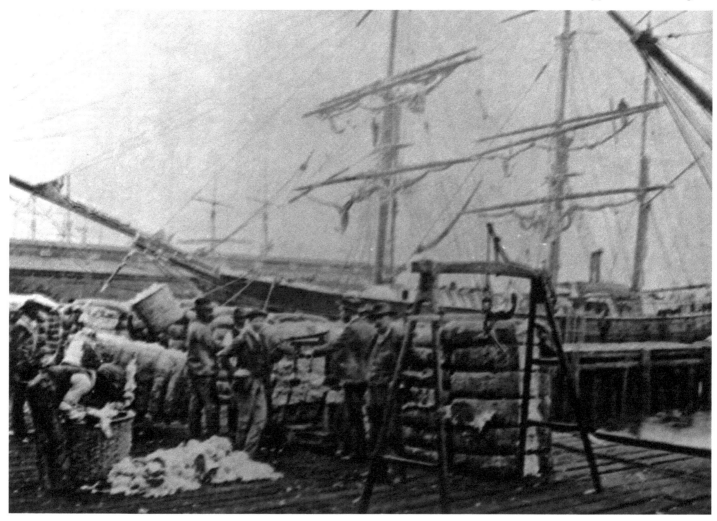

Nurses and doctors gather in front of City Hospital at Tenth and Red Cross streets in the 1890s. Two of the men have been identified, Jim Hall at left and Dr. C. P. Bolles at center.

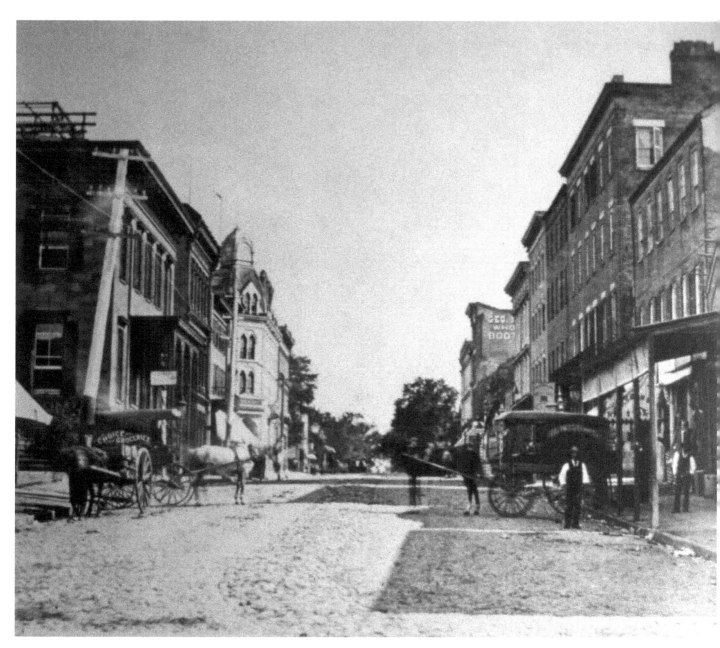

This view is north on Front Street between Market and Princess streets around 1891. A left turn onto Market would leave a pedestrian a quick walk to the ferry landing that serviced Eagle Island and the west side of the Cape Fear River.

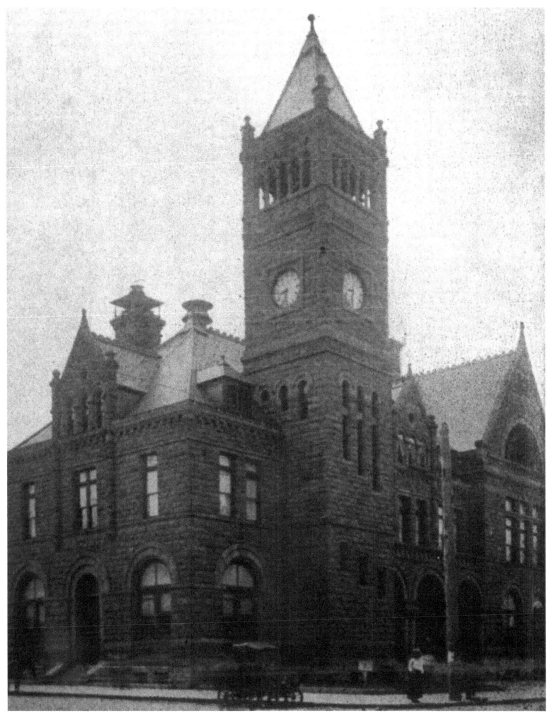

Built in 1889, the old Post Office (pictured in 1891) stood at the corner of North Front and Chestnut streets. The destruction of this beautiful granite building in 1936 created quite a furor. Many citizens wished to preserve this monument to 1890s architecture, but an even larger group saw a need to create jobs during the Great Depression by demolishing the old and building anew. The unemployed won.

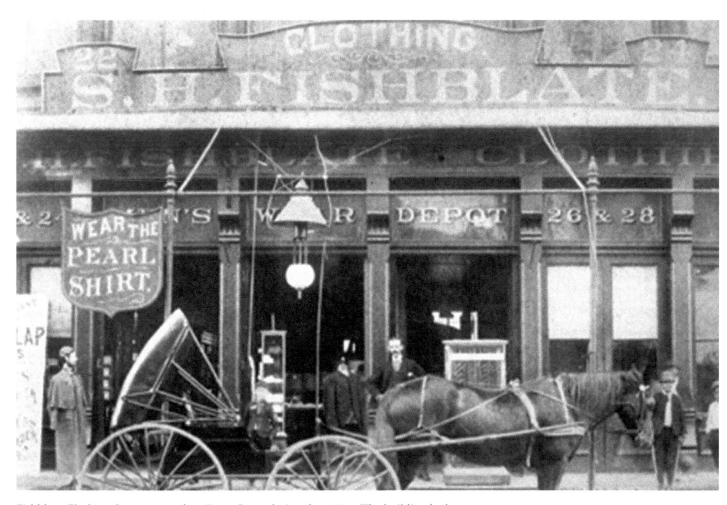

Fishblate Clothing Store operated on Front Street during the 1890s. The building had a cast-iron front, an architectural style of the mid to late 1800s.

This shot of Water Street (right) and the Cape Fear River was taken from the back of the Dudley mansion on Front Street in the late 1890s. The wharf at center shipped barrels of tar and turpentine. The mansion, former home of Governor Edward B. Dudley, would have been owned by Pembroke Jones at the time of the photograph.

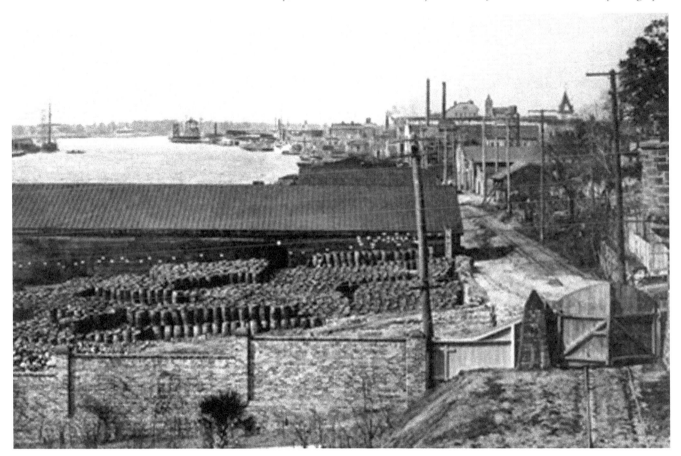

The horse and buggy remained a fixture in Wilmington well into the 1900s. In this idyllic 1890s residential scene, a woman reads on the steps as the gentleman pauses for a moment of admiration.

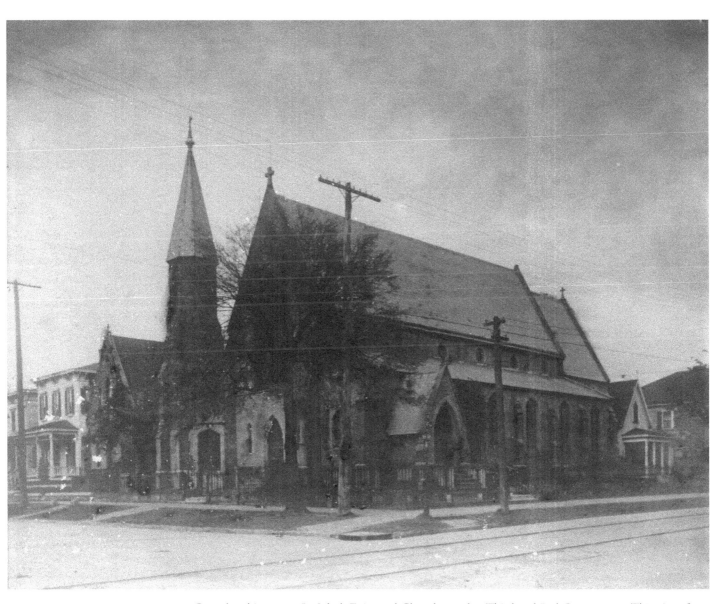

Completed in 1853, St. John's Episcopal Church stood at Third and Red Cross streets. This view, from the late 1890s, shows the trolley tracks that ran along Red Cross Street and utility poles for telephone and electrical lines. In 1955, the congregation moved to a new building.

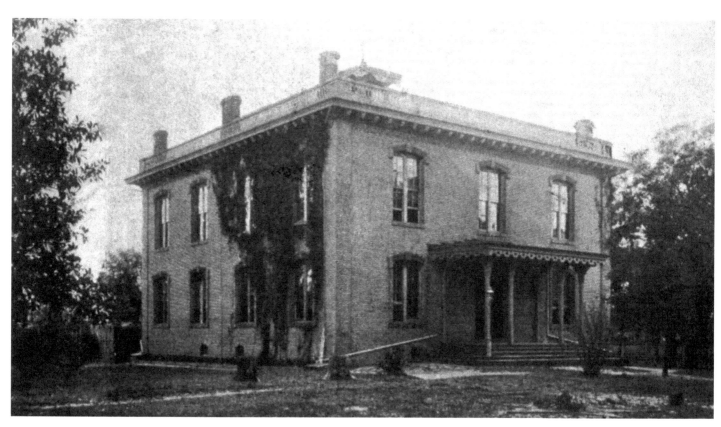

Located on Anne Street between Fourth Street and Fifth Avenue, Tileston Elementary School opened in 1872. From 1900 to 1921, it served as Wilmington High School.

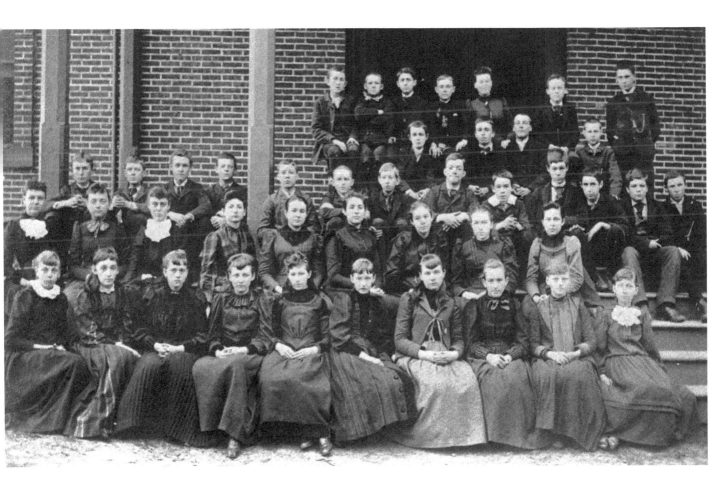

Older students pose on the steps of Tileston Elementary School in the late 1890s.

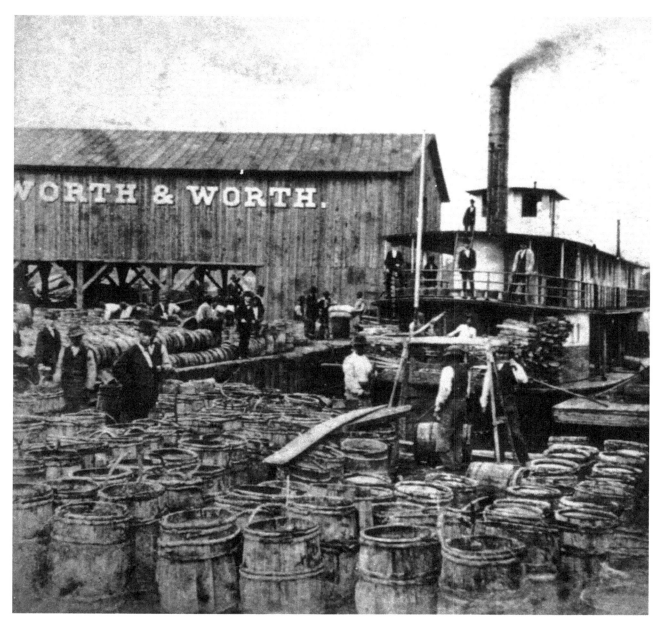

A steamboat unloads barrels of rosin in 1896 at the docks of Worth & Worth (established in 1852), after loading them along the Cape Fear and its tributaries that meandered through the great pine forests of eastern Carolina. Worth & Worth served as agents for the Cape Fear Steamboat Company, storing and transporting the state's agricultural bounty. They also built several steamships: *Flora McDonald, A. P. Hurt,* and *Governor Worth.*

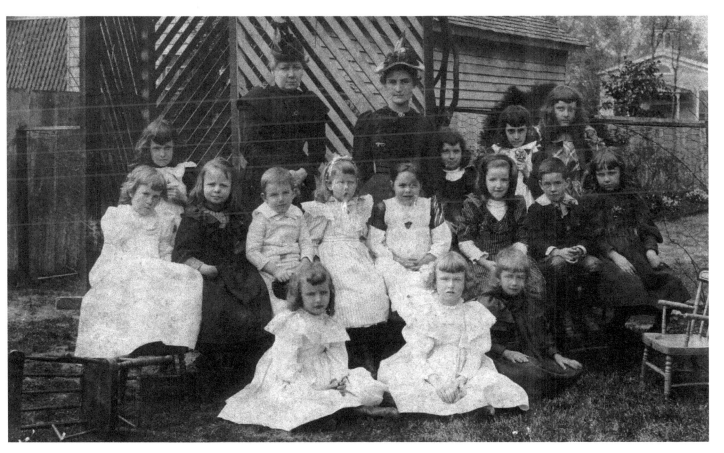

Schoolchildren and two teachers pose in a garden in 1894. The two lads seem a bit subdued—no pulling of pigtails when that heavily outnumbered!

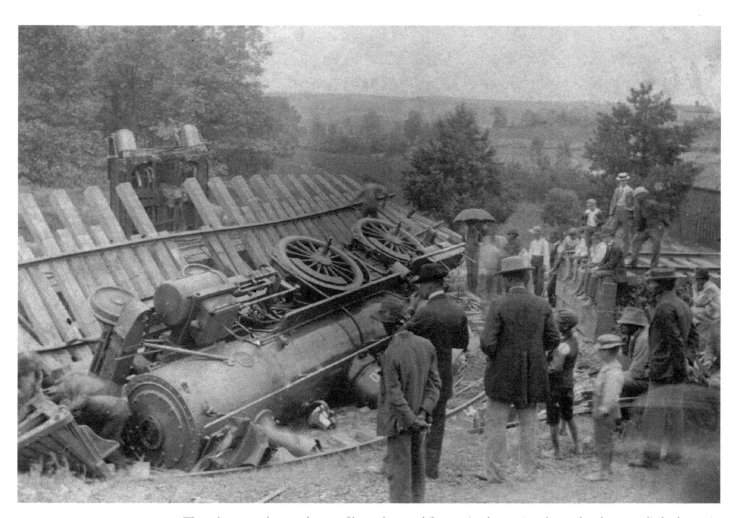

Though cowcatchers took care of bear, deer, and farm animals crossing the tracks, there was little that train engineers could do about washouts beneath railroad embankments—other than be vigilant. This wreck, around 1899, resulted from erosion caused by heavy rains in the Wilmington area.

The Spanish-American War in 1898 brought more naval traffic than usual to Wilmington. The crew of a dynamite launch (a torpedo boat) takes the opportunity afforded by harbor and a lovely day to wash, dry, and mend their clothing.

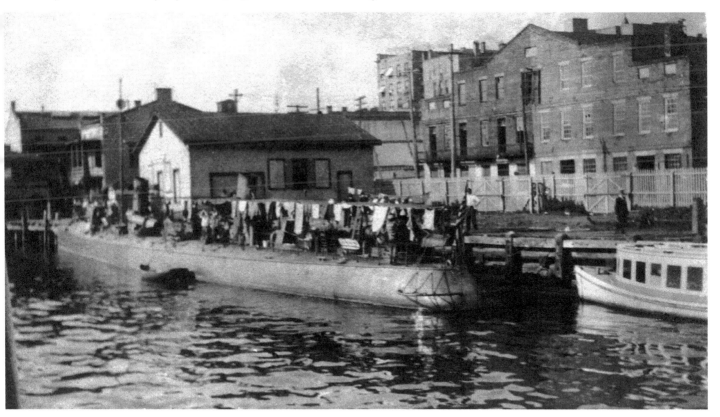

One of the ugliest episodes in Wilmington history occurred on November 10, 1898. Democrats and white supremacists combined forces to overthrow the local Republican government. Attackers murdered at least seven black citizens during the riot, while numerous black families fled the city. In this picture, some of the men responsible for the coup d'etat stand outside the wreckage of the black-owned newspaper, the *Daily Record*.

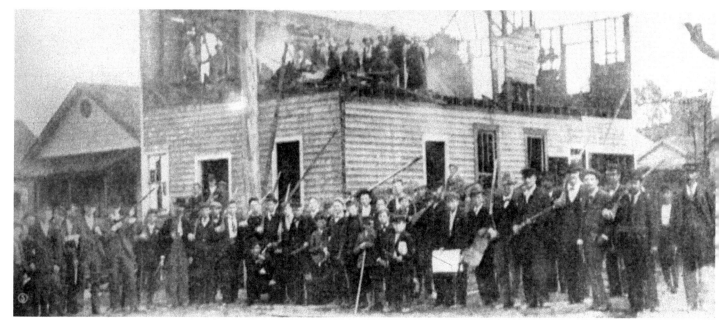

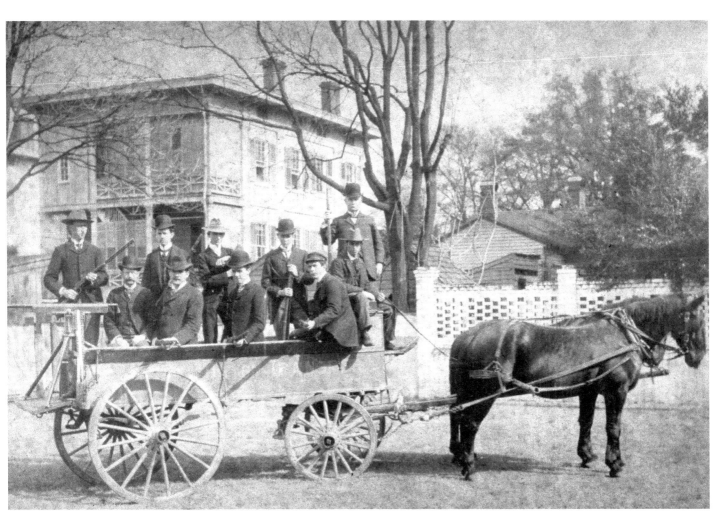

Groups of well-armed men guarded roads leading from Wilmington on November 10, 1898, hoping to capture key white and black Republican leaders attempting to flee the city. Alexander Manly, editor of the *Daily Record,* managed to escape in the darkness, aided by his light skin color. Other leaders were not so lucky.

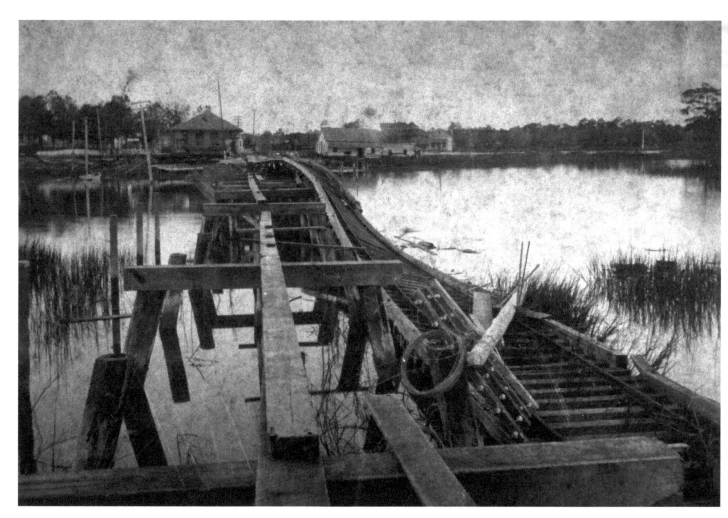

A late-season hurricane, known locally as the "Big Storm of 1899," struck the Wilmington area on November 1. Loss of life accompanied tremendous local damage, including the destruction of the railroad trestle of the Wilmington Sea Coast Railroad that had linked Wilmington and Wrightsville Beach since 1889. An electric trolley line replaced the railroad in 1902.

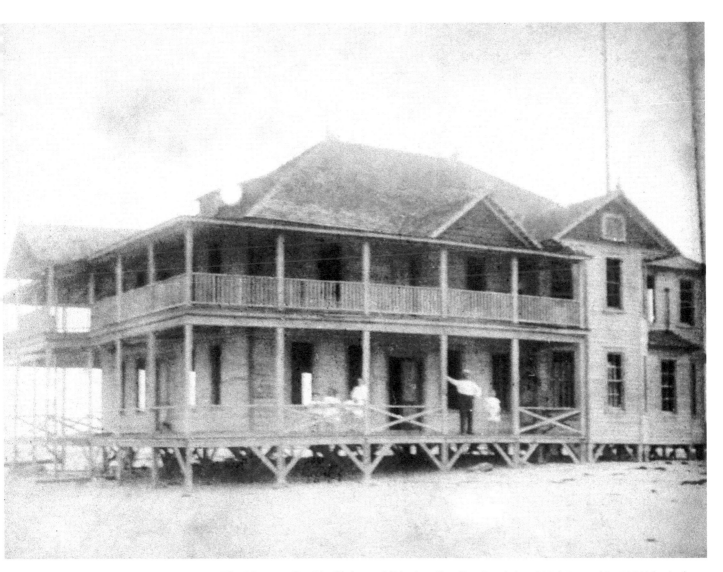

The Hanover Seaside Club, established at Carolina Beach in 1898 (pictured in 1899) had a large membership. Carolina Beach rapidly developed as an alternative to crowded Wrightsville Beach for the citizens of Wilmington, who enjoyed the undertow-free swimming, good fishing, and day-long excursions on the 500-passenger steamer *Wilmington* (operating on the river after 1891).

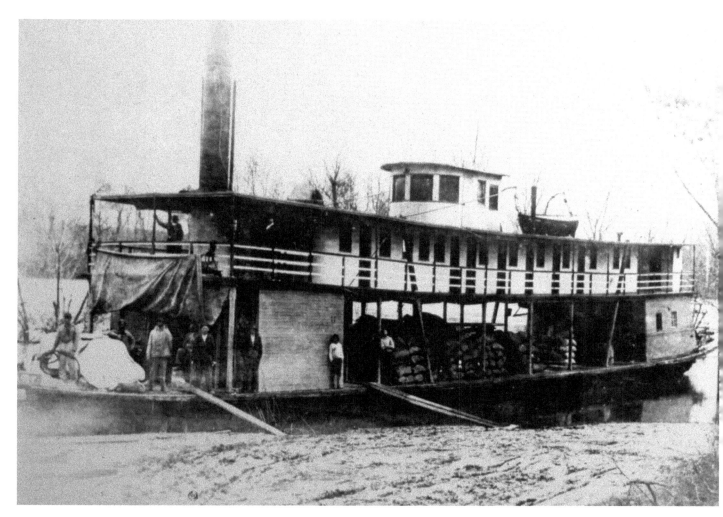

The steamer *A. P. Hurt,* shown here in the late 1890s, carried passengers and goods along the Cape Fear River for Worth & Worth. A steamer of this name operated on the river from the 1860s until 1923. Rebuilt at least once during this period, the modifications allowed the steamer to carry 140 tons. Such flat-bottomed sternwheelers (and, later, propeller-driven steamers) opened the Carolina interior to the Port of Wilmington.

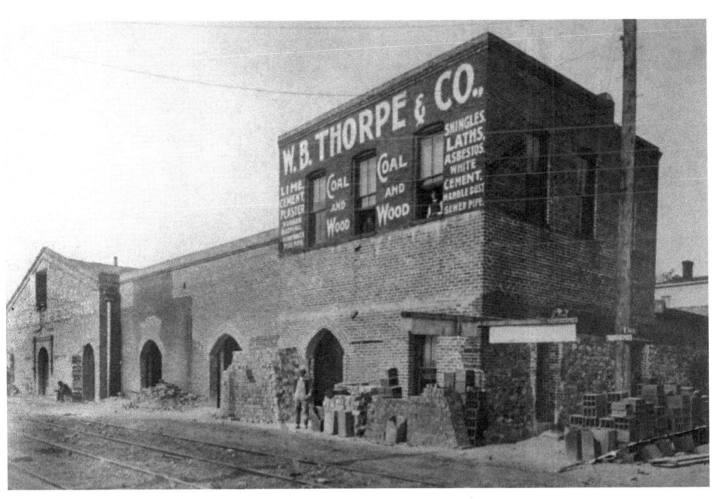

W. B. Thorpe & Company stood at the northeast corner of Water and Anne streets. Offering construction materials to the locals, it also carried coal and wood to replenish steamers. Today, the lower floor of this building houses several shops in the area along Water Street known as Chandler's Wharf.

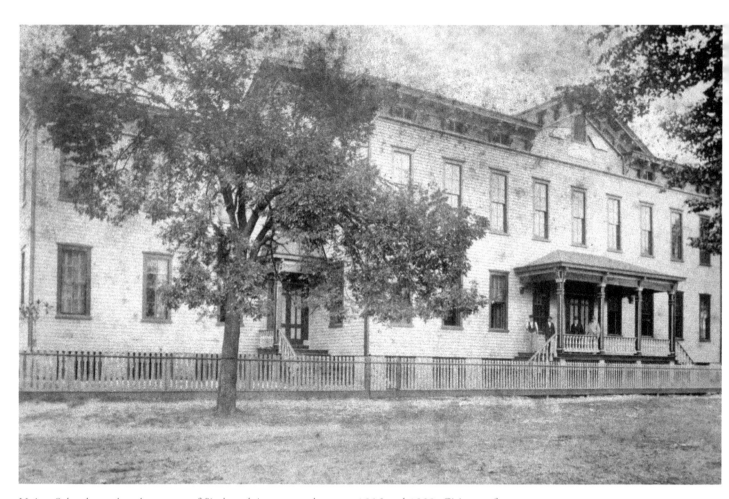

Union School stood at the corner of Sixth and Ann streets between 1886 and 1923. Citizens of
Wilmington referred to it as "Big Union School" to distinguish it from a smaller school of similar name,
Union Free School, built along Sixth Street in 1857.

By 1899, the railroad complex at Wilmington, filling several blocks around Nutt Street, Front Street (the site of Union Station), and Red Cross Street, had grown to meet the needs of a thriving port and vacation destination. The next year, the old Wilmington & Weldon merged with the Atlantic Coast Line. That company also chose to make its headquarters in the Port City.

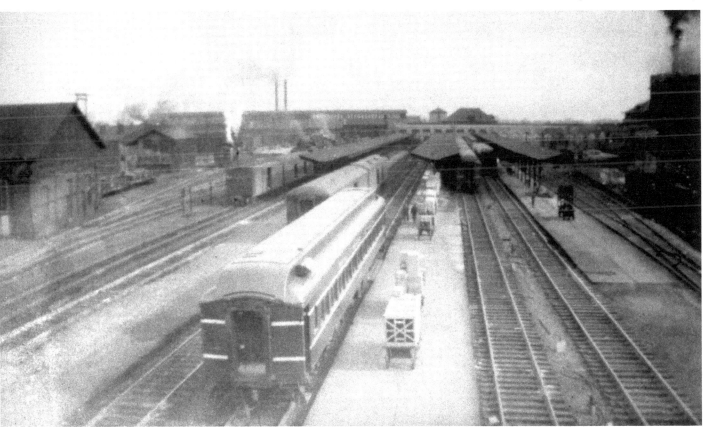

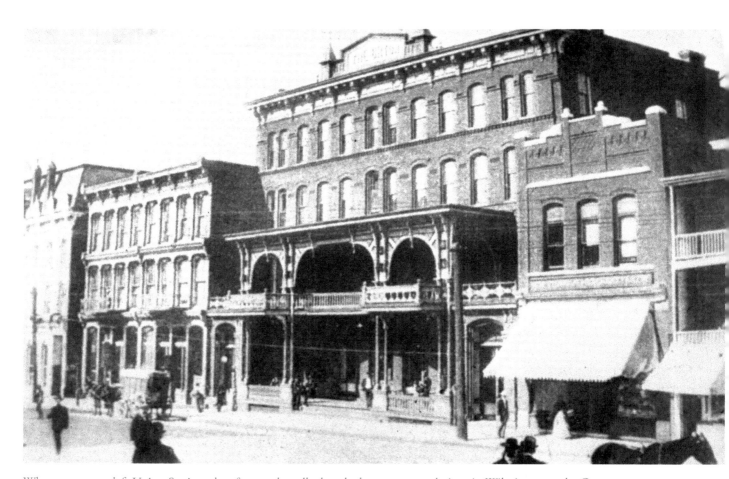

When passengers left Union Station, they frequently walked to the best accommodations in Wilmington—the Orton Hotel at 115 North Front Street. Built in 1886, the Orton maintained a reputation as the finest hostelry in the city until the 1920s. A fire in 1949 gutted the building, which the city subsequently razed owing to safety issues.

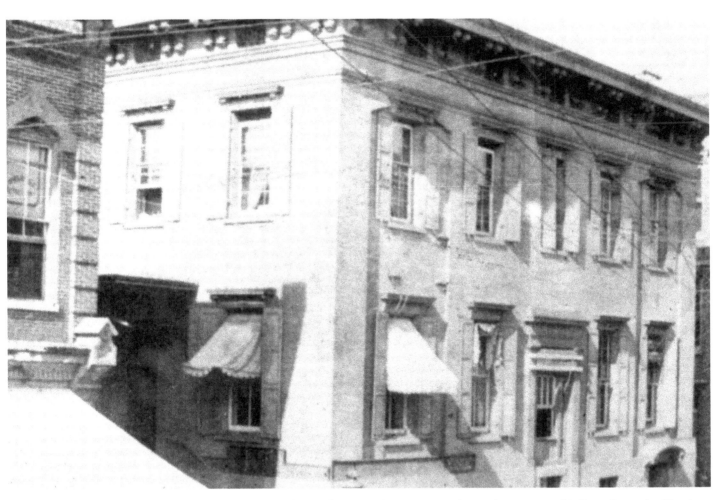

Built as the residence of eighteenth-century merchant John Ancrum, this Front Street dwelling later housed the Cape Fear Bank and the First National Bank before being demolished in 1899 to make way for the Masonic Building.

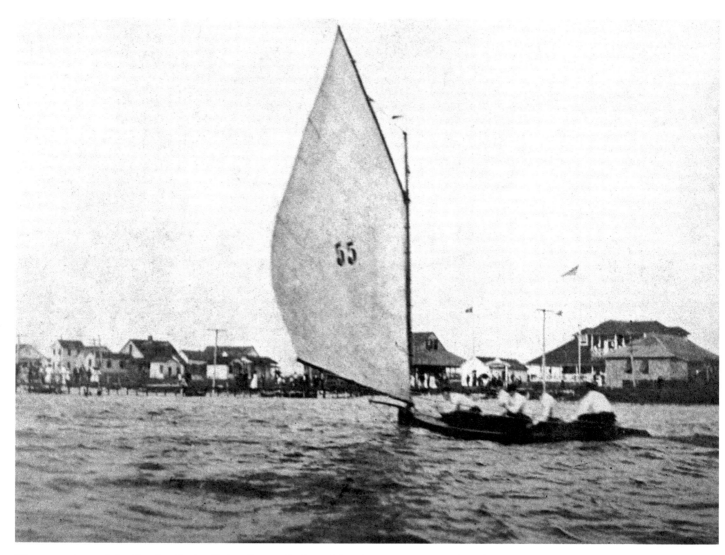

These members of the Carolina Yacht Club sail away the last of the Gay Nineties in Bank's Channel. The club and its docks are in the background. Founded in 1853 at Wrightsville Beach, the yacht club is the second oldest in the United States.

A New Century and New Beginnings

(1900–1916)

The early years of the twentieth century found Wilmington among the most prosperous of North Carolina cities and towns. Its extensive docks, linked to the interior by the Cape Fear River and no less than five railway companies, shipped worldwide and received goods in like measure. By 1916, automobiles lined its streets and, with the state government's new emphasis on roads, it appeared that the long-awaited traffic bridge across the Cape Fear would soon be built. For those who lacked the money or nerve to purchase the new-fangled machines, an electric trolley reached many city streets as well as Wrightsville Beach. For less crowded beaches, excursion boats docked at Water Street. Even the newest mode of transportation, by air, found visionaries in the Port City.

Merchants, and some light industry like Hanover Iron Works, found prosperity along Front and other streets in the business district. Many of these merchants stayed in business in the same storefront for more than twenty years—a mark of Wilmington's stability as well as its economic success. The city also boasted several dozen saloons (it was a port, after all), but they closed after 1908 when North Carolina voted to become a "dry state" (well before national prohibition).

Hammers constantly banged around Wilmington as new, and frequently impressive, buildings rose to change the waterfront skyline. In 1912, for example, the new office and terminal building of the Atlantic Coast Line was completed, as well as the Trust Building—the Port City's first "skyscraper." A new Customs House in 1916 completed the new design.

From baseball teams to presidents, Wilmington became a "destination" in the early 1900s. Notables and dignitaries—such as President Taft in 1909—formed only a tiny percentage of the Port City's visitors. Most passed through on their way to Wrightsville or Carolina Beach or sandy spots in between the two. Thus tourism became an important part of the region's culture.

However, 1914 brought a world war which threatened Atlantic shipping lanes and trade: a fact not lost on a place that called itself the Port City. From shipping magnates to moms, dads, and sweethearts, an almost palpable stress held sway in Wilmington as its citizens waited for 1917 and hard decisions by a man at least partly raised in that very town, President Woodrow Wilson.

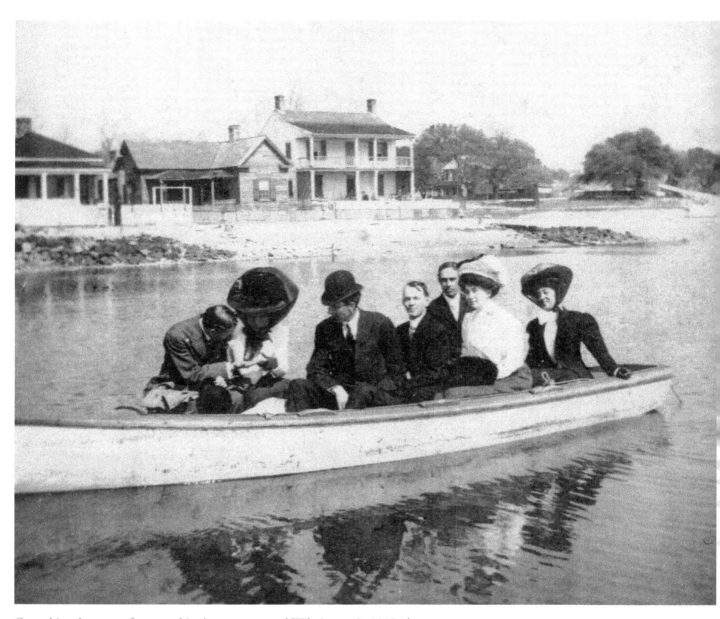

Courtship takes many forms, and in the waters around Wilmington in 1900, that meant an afternoon (chaperoned, of course) floating peacefully along the sound or local creeks.

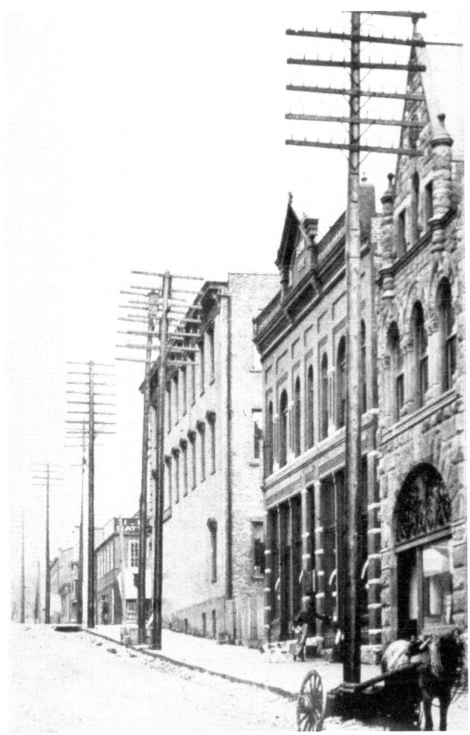

The coming of electricity brought refrigeration, and with refrigeration came commercially produced ice cream. In 1900, Arctic Ice Cream Company stood on the south side of Princess Street between Water and Front streets. Delicious stuff on a hot, humid Carolina day!

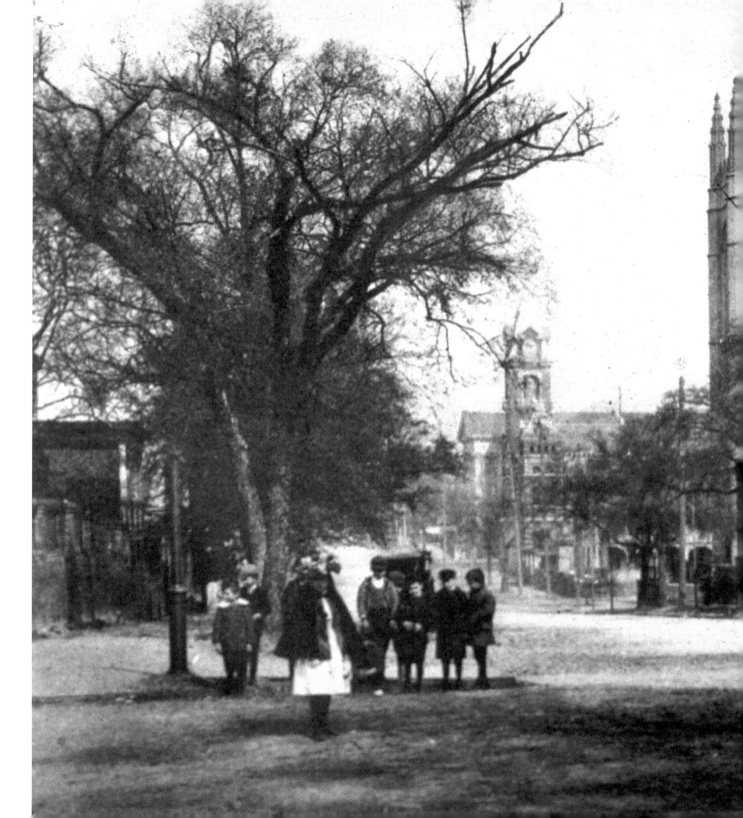

This photograph of the south side of Third Street, facing Market Street, reveals a road not yet paved in 1900. On the right is the Hill-Wootten House (built in the early 1800s and demolished in the 1950s). Beside it stands St. James Episcopal Church, constructed in 1839. It replaced the original church building on the site that dated to 1769.

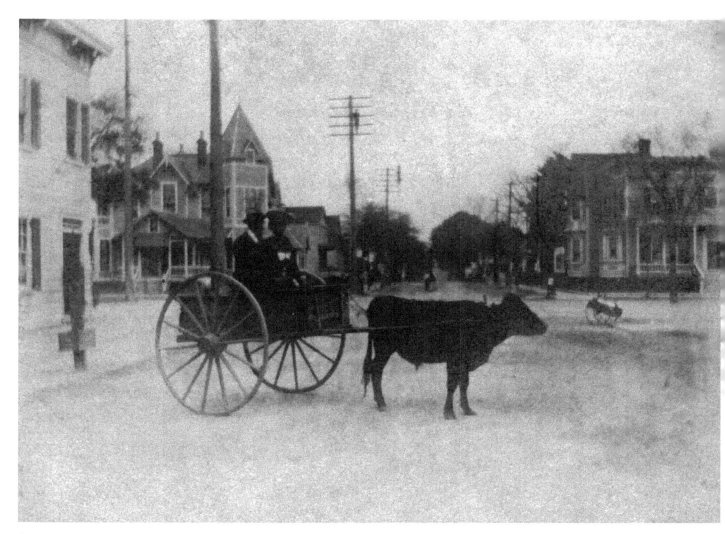

Sometime between 1900 and 1910, an ox cart and passengers pose for a photograph at the corner of Market and Seventh streets. B. H. J. Ahren's store is open for business on the left and the S. Solomon home stands across the street.

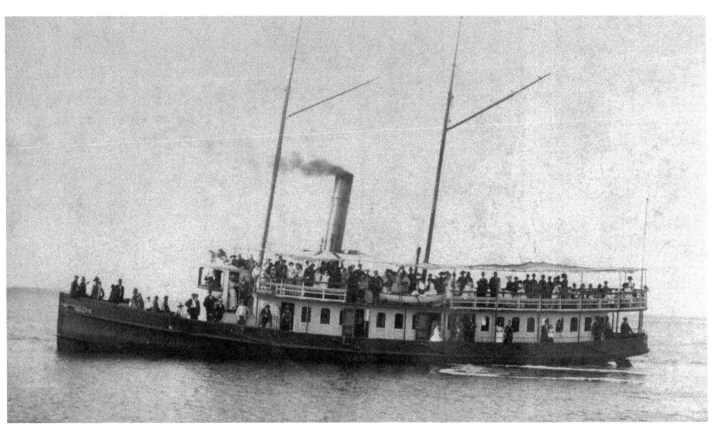

One of several excursion boats operating from Wilmington around 1900, the steamer *Passport* is "standing room only" as it cruises the Cape Fear River, possibly heading to popular Carolina Beach.

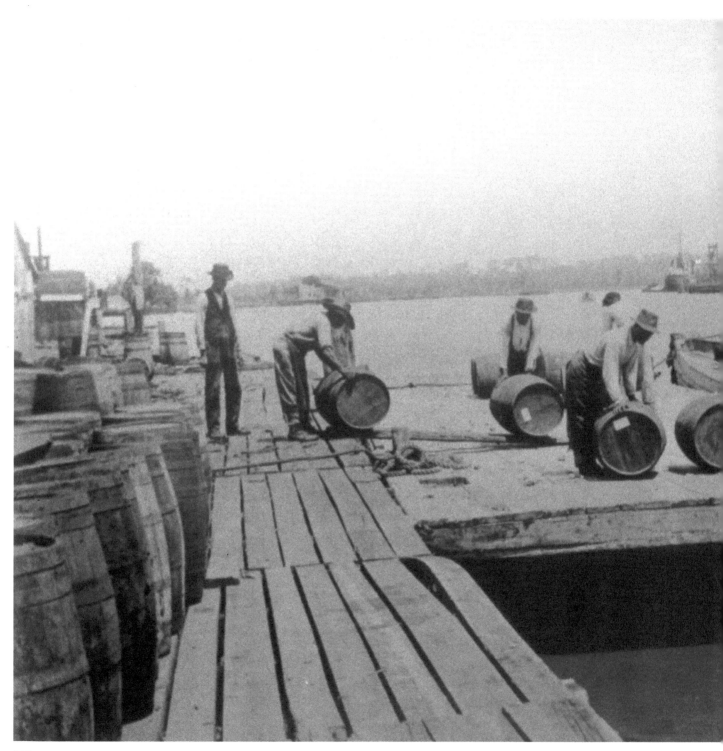

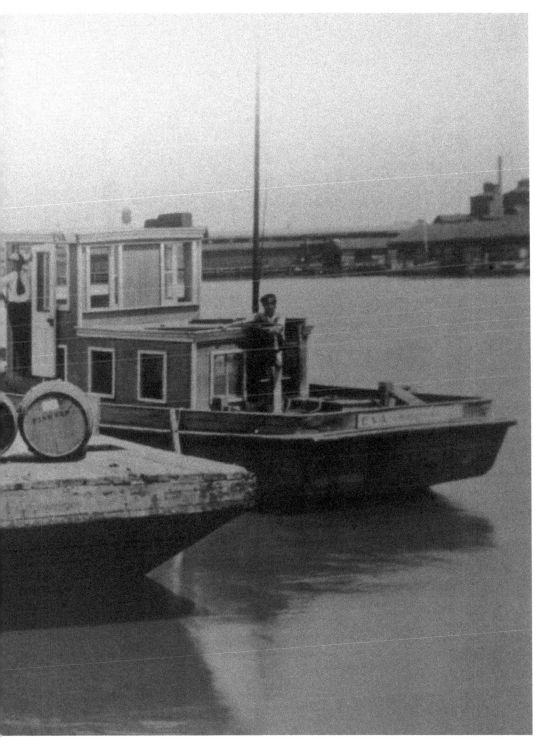

Laborers load barrels onto a "lighter," possibly at a wharf on Eagle Island, around 1900. Lighters transported goods to and from ships that were too large, or for other reasons unable, to reach the wharf.

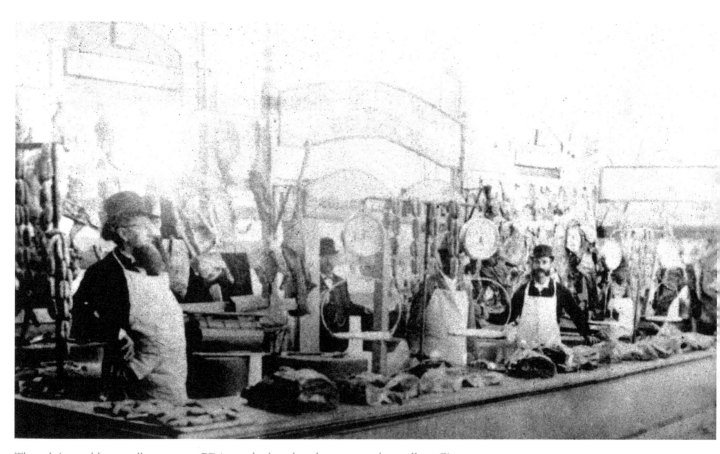

Though it would assuredly not meet FDA standards today, the meat market stalls at City Market House on Front Street provided protein to city dwellers, scraps to the city's stray dogs, and an interesting aroma to all.

Built in the 1880s, the Alexander Sprunt and Sons Business Office occupied the northeast corner of Front and Walnut streets. The company, the largest cotton-export operation in the world in 1900 (about the time this photograph was made), owned offices in Wilmington, Liverpool, and Berlin. The Sprunt's Wilmington business, as a whole, filled two square blocks near and along the riverfront. A new office (part of the Cotton Exchange today) replaced this building in 1921.

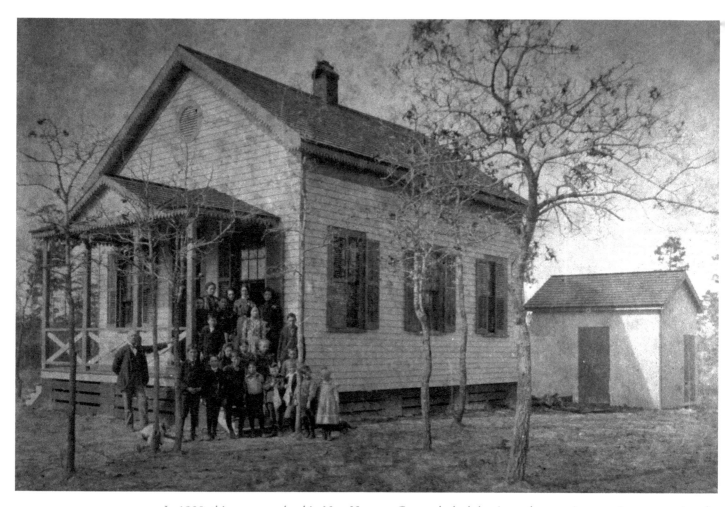

In 1900, this country school in New Hanover County lacked the size and pretentiousness (not to mention the funding) of the Port City's schools. In the 1920s, county and city consolidated their educational systems, eliminating some existing inequalities. The final inequality in education—segregation—had to wait until the 1970s.

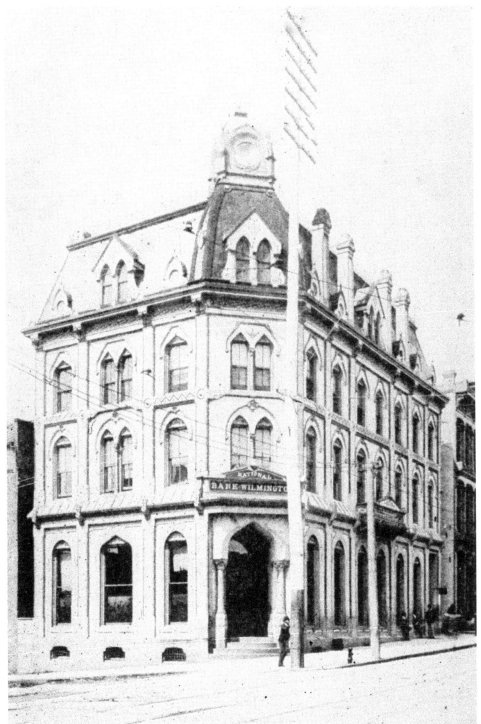

This is a view of the People's Savings Bank (later Peoples Bank and Trust) around 1900. The building, at the corner of Front and Princess streets, dated to 1873, at which time it held the Bank of Hanover. Demolished in 1959, the old building was replaced with a Wachovia Bank.

The old First Presbyterian Church at the corner of Third and Orange streets dominates this view along South Third Street around 1900. Completed in 1861, the building was destroyed by fire on the last day of 1925. Joseph Wilson, father of President Woodrow Wilson, ministered to the members from 1874 to 1885.

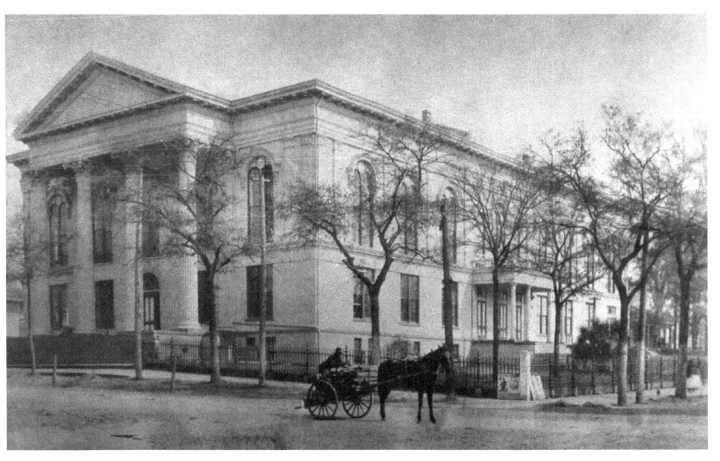

Completed in 1858, City Hall occupies the northeast corner of Third Street. Built in the Classical revival style popular in the mid-1800s, it contained a thousand-seat Opera House as well as room for city offices. This photograph, taken in 1900, shows the impressive Corinthian columns associated with the architectural style.

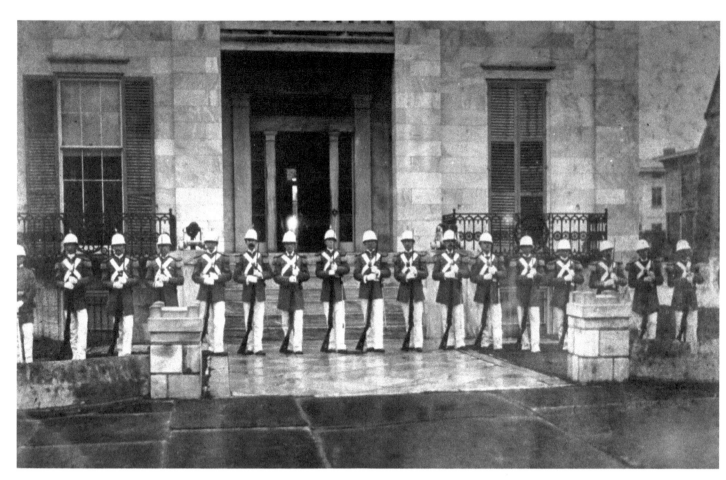

An Honor Guard or Burial Detail of the Wilmington Light Infantry turns out in this turn-of-the-century photograph. The WLI dated their beginnings to 1853. They served as Company G of the 18th North Carolina Infantry Regiment during the Civil War; as Home Guard during the Spanish-American War; and in Battery C, Second Battalion, Trench Artillery during World War I.

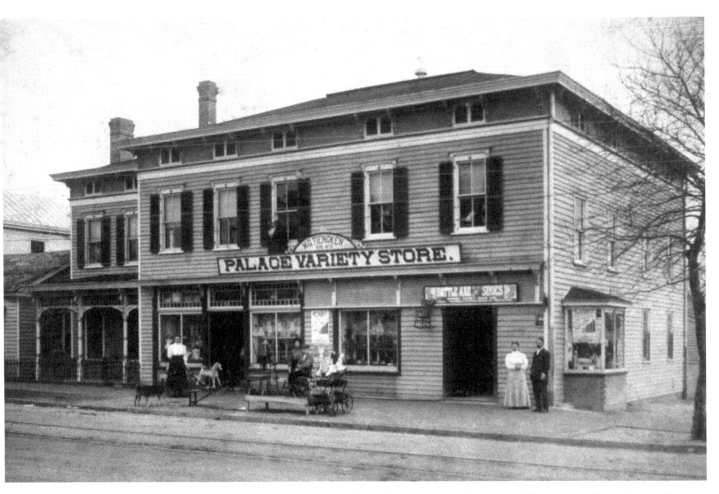

M. G. Tiencken's Palace Variety Store on the corner of Fourth and Castle Street offered, as the name implied, a large variety of goods in 1900. Like many business owners of the time, the family lived above the shop.

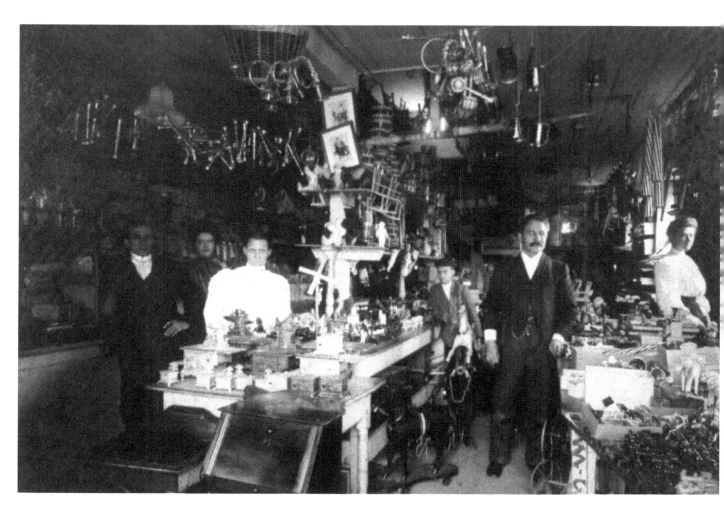

Inside M. G. Tiencken's Palace Variety Store in 1900, merchandise of all kinds—from wicker baskets to hobbyhorses—was available for purchase.

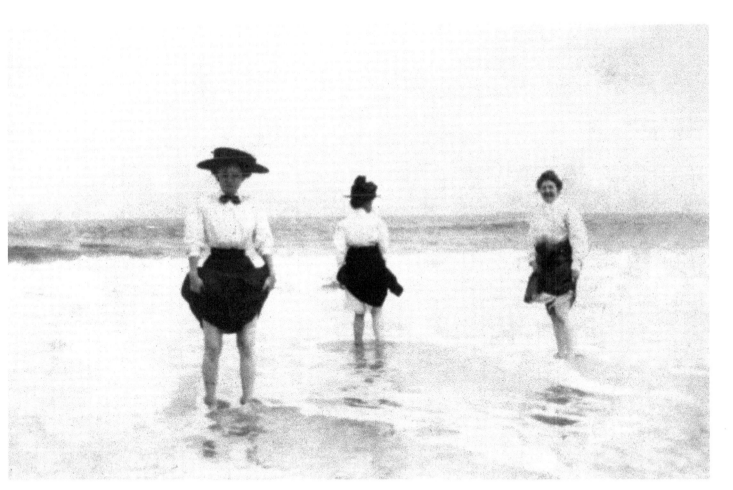

Women wade in the ocean at Wrightsville Beach. Daringly for the time, they give us a flash of—knee!

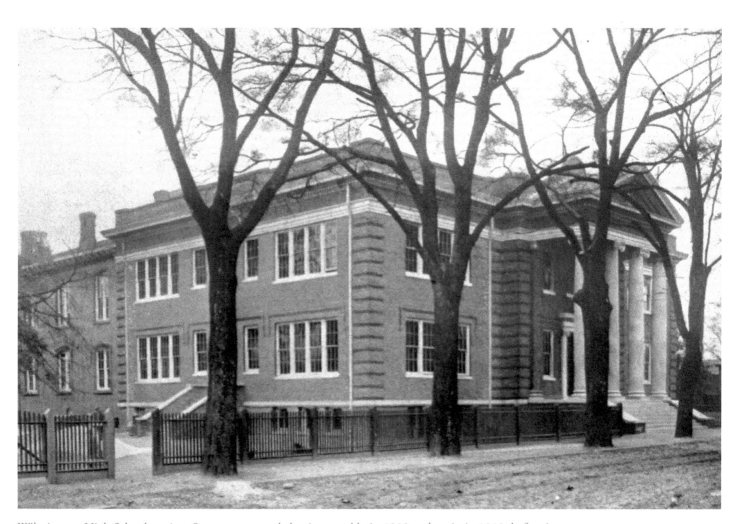

Wilmington High School on Ann Street was expanded twice, notably in 1903 and again in 1910, before its replacement with New Hanover High School in 1921. A sketch of the expansions suggests that this photograph was taken around 1905.

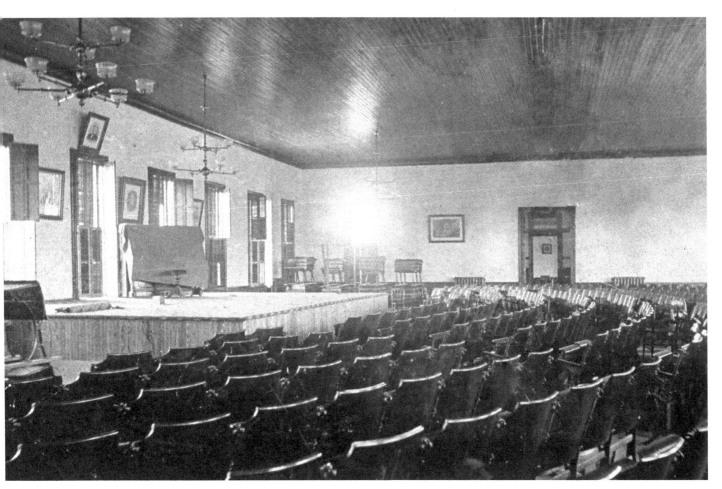

The large auditorium of "Big Union School" echoed to the sound of plays and recitals in the early 1900s.

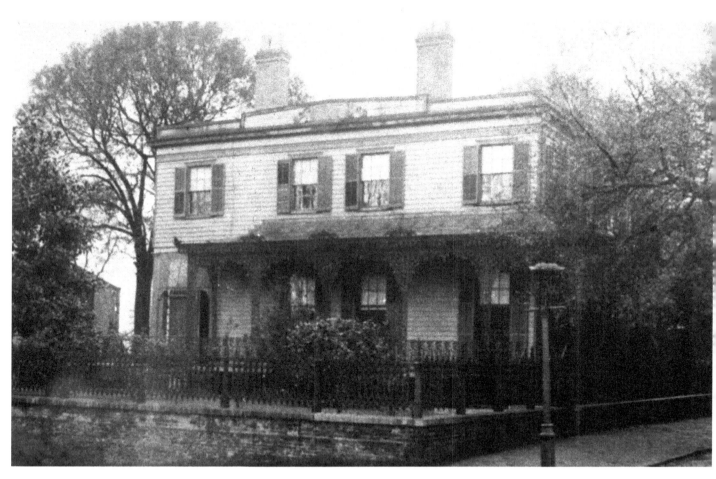

The Cape Fear Club, the oldest Gentlemen's Club in North Carolina, was organized in 1866. From 1888 to 1913, the club met in the James Dawson House at the northwest corner of Front and Chestnut streets (pictured here). In 1914, the gentlemen relocated their clubhouse to 206 Chestnut Street.

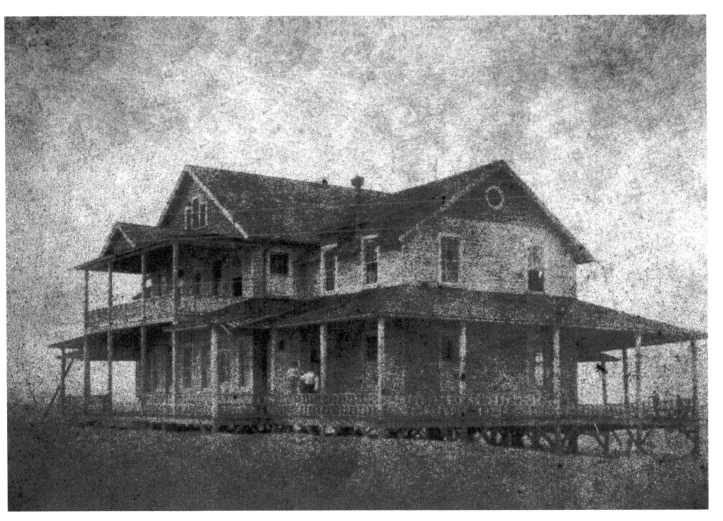

Formed in 1898, the Hanover Seaside Club at Carolina Beach offered an alternative to Wrightsville Beach. Only ten miles from Wilmington, Carolina Beach gained in popularity as its commercial area developed through the early 1900s.

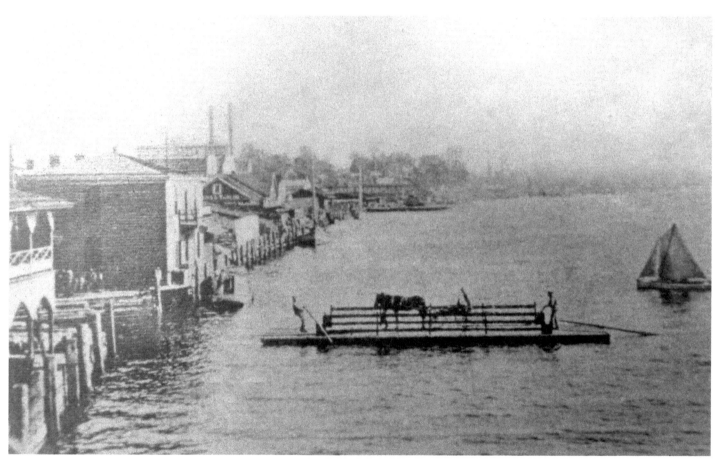

Until the bridging of the Cape Fear River, cable-ferries operated from the base of Market Street.
Shortly after 1900, this horse and buggy crossed to Wilmington on a flat-ferry for a day of
business and pleasure.

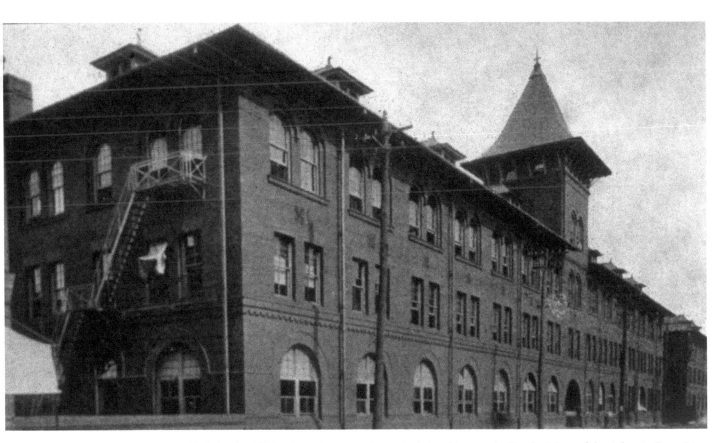

Built in the 1880s, the unique steeple marked the old general office building of the Atlantic Coast Line Railroad on Front Street. In the early 1900s, the railroad guaranteed employment for Wilmington's citizens, and introduced many tourists to the delights of the Port City and its adjacent waters. It was demolished in 1962.

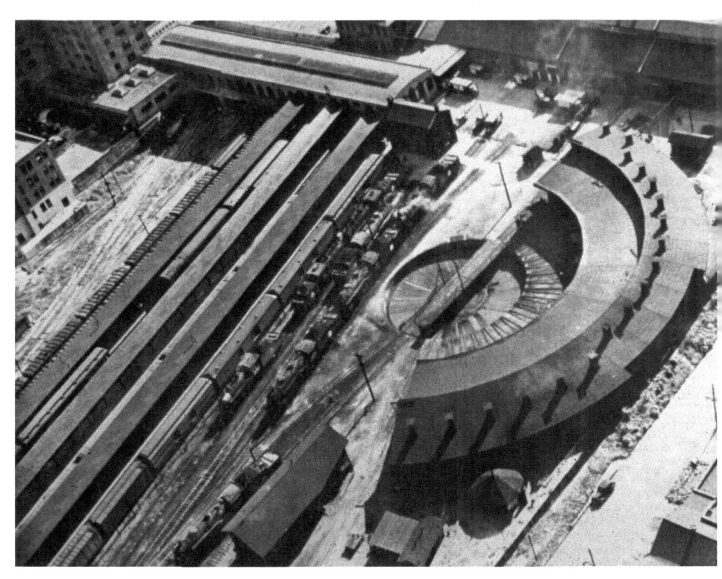

As a terminus for the Atlantic Coast Line, the rail yard at Wilmington featured a roundhouse and turntable, so that engines could be pivoted to haul cars away from the city.

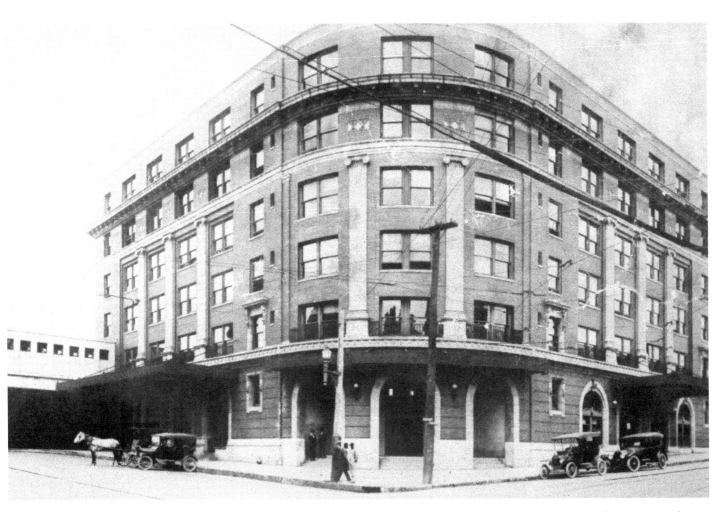

Union Station was the first (or last) stop for travelers on the Atlantic Coast Line. It curved around the northeast corner of Front and Red Cross streets (across Front Street stood the general office building). The headquarters of the ACL occupied the upper floors until 1960, when it relocated to Florida. The building was imploded in 1970 with explosives. This picture, from around 1909, illustrates changing times in Wilmington: horse and buggy at left, automobiles at right.

This view of North Front Street in the mid-1900s shows the upper stories and roof of the Masonic Building at lower left. The white structure in the center is the Southern Building, while the Murchison National Bank Building looms at upper center. The steeple of the Atlantic Coast Line's general office building is visible in the distance on the east side of the street, while the Cape Fear flows to the west.

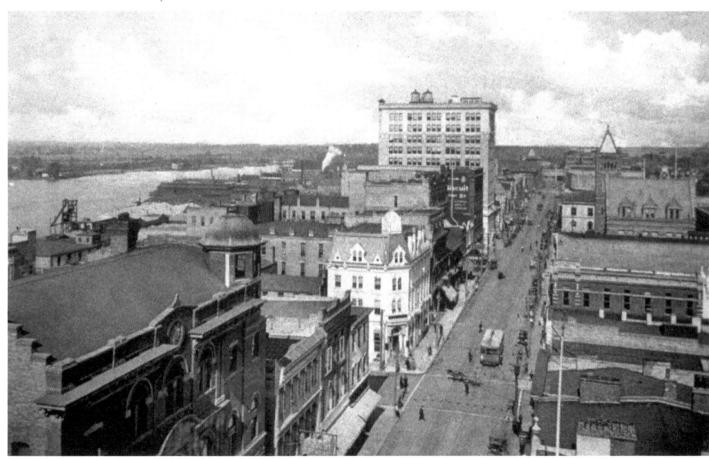

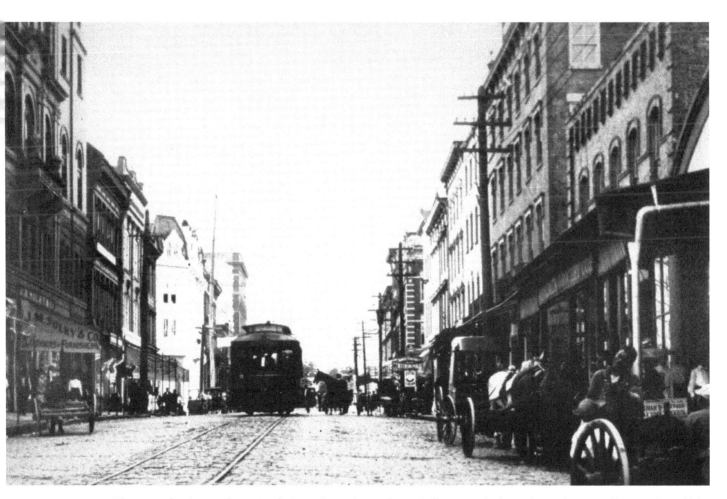

This street-level view along North Front Street (around 1905) illustrates the heavy horse-drawn traffic over the cobbles of the period in the main business district of the Port City. Note the electric trolley lines in the center of the street and the utility poles, both signs of a vitality and wealth not common to every Carolina town. The Southern and Murchison buildings are visible on the distant left. The Purcell House Hotel stands at right.

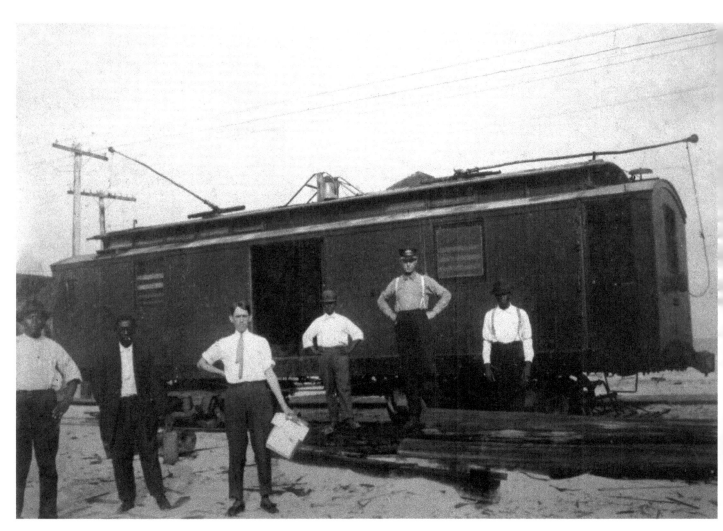

Baggage handlers load a trolley car destined for Wrightsville Beach sometime after 1902. On a normal day, from the 1890s to 1939, Tide Water Power Company operated the trolley system in Wilmington beginning at 6:00 A.M. every morning. In 1902, the company added seven stops at Wrightsville Beach, ending at the popular Lumina Pavilion.

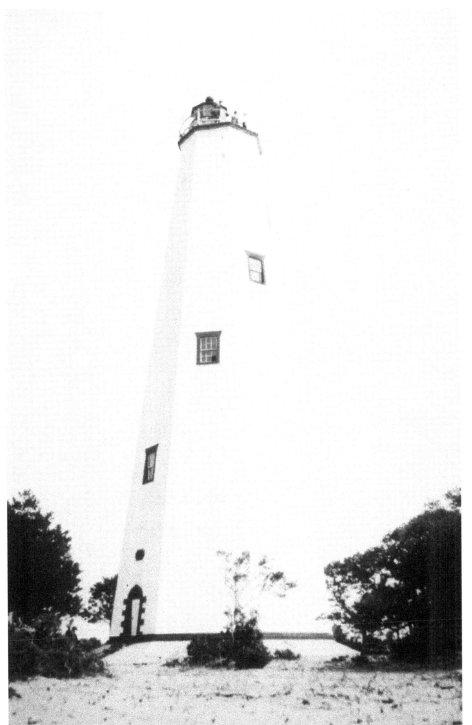

Completed in 1818, the Bald Head Island Coast Guard Tower stood off the mouth of the Cape Fear River, warning sailors of the dangers of Frying Pan Shoals and the coast. Except for the years of the Civil War, it operated until 1935.

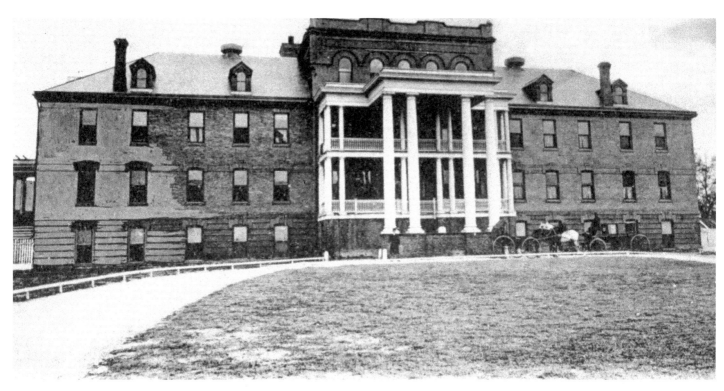

Pictured in 1904, the original James Walker Memorial Hospital opened in 1901 at Tenth and Red Cross streets. Constantly expanded across the years, only the Nurses Residence Hall survived its demolition in 1972.

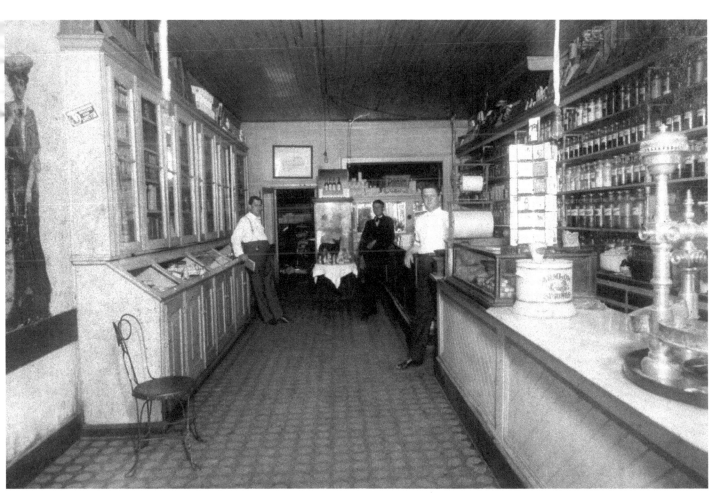

Located on Market Street between Front and Second streets, Shepard Pharmacy filled prescriptions and offered mass-produced remedies as well as carrying a well-stocked ice cream freezer.

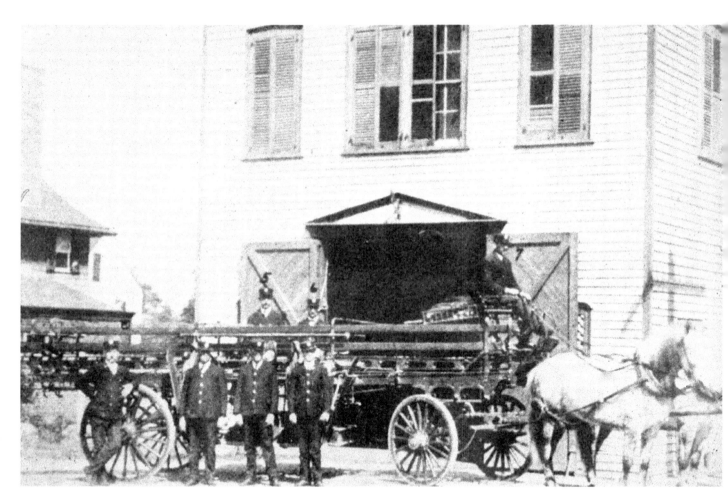

Although the first volunteer fire companies were organized in the city in 1856, only in 1897 did the Port City form a fully paid, professional fire department. In 1905, this horse-drawn hook and ladder wagon represented state-of-the-art technology as its crew posed in front of the old fire house at 301 Dock Street. Within five years, however, shiny trucks began to replace the hay-eaters.

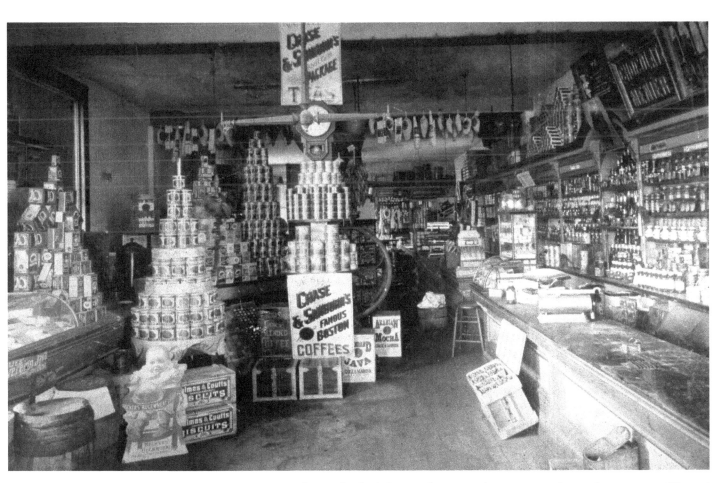

In 1905, Simon Sanders' Grocery Store served customers at the northeast corner of Second and Market streets. Such "Mom and Pop" grocers served the needs of communities long before the coming of the modern supermarket. They usually depended on local farmers for fresh vegetables and meats, but Wilmington's location on the Atlantic Coast Line offered other sources for its merchants.

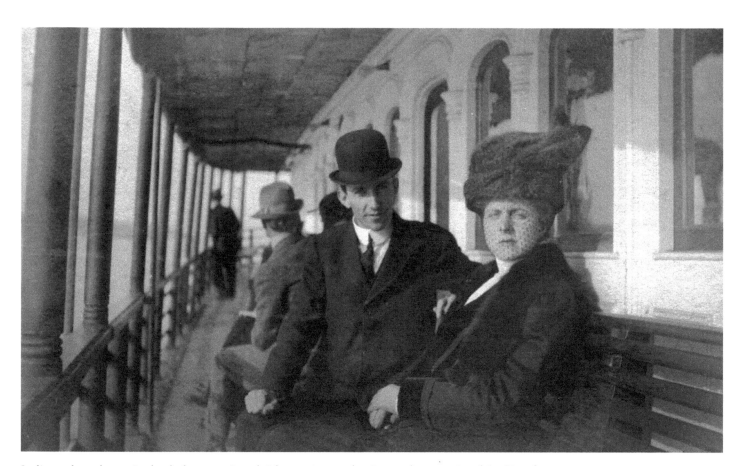

Ladies and gentlemen in the deck seats enjoy a brisk morning on the river as the excursion ship *City of Wilmington* makes its way to Carolina Beach and Southport around 1905.

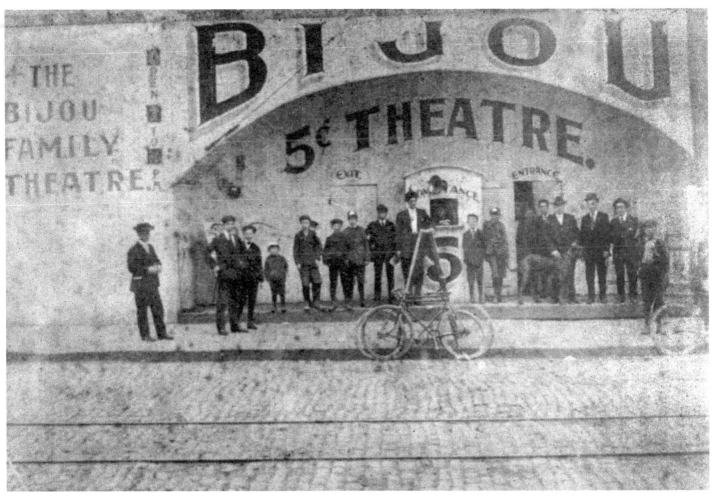

Built on the site of the old Cowan House on North Front Street between Chestnut and Grace streets, the Bijou Theatre billed itself as the "First Permanent Moving Picture House in North Carolina." The term "permanent" is questionable—the theater stopped showing pictures in 1956 and fell to the forces of urban renewal in 1963. This photograph was taken sometime after 1906, the year the Cowan House was demolished.

Founded in 1896 by Colonel Walker Taylor, the Brigade Boys Club modeled itself on a similar Scottish organization. Originally, the only criterion for joining was membership in a Sunday school class and regular attendance. Shown here in uniform, the young men and their instructors pose for the photographer in 1906.

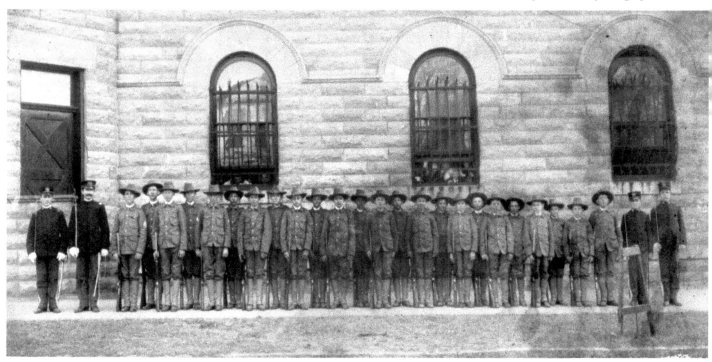

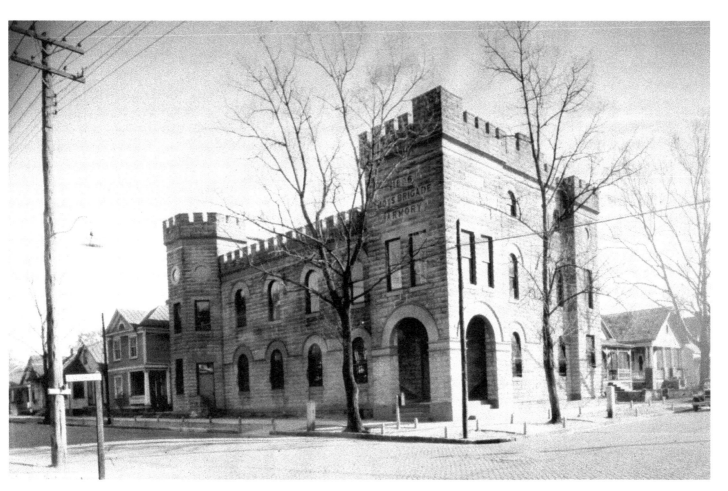

The Brigade Boys Club Armory is pictured a few months after its dedication in 1905. Standing at the corner of Second and Church streets, it remained in use until 1950. Today, the Brigade Boys Club has both male and female members and is affiliated with the Boys and Girls Club of America.

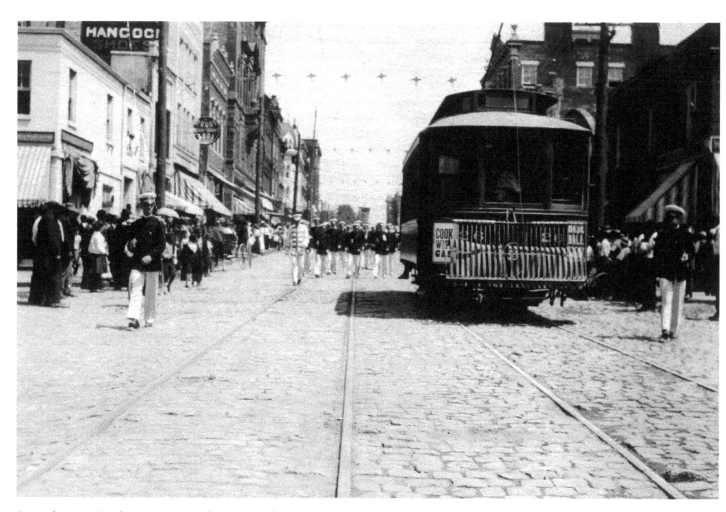

A parade, sometime between 1900 and 1913, marches alongside a trolley car near the intersection of Front and Market streets. Though cobblestones had not yet given way to asphalt (a sure sign of increased automotive traffic), Wilmington had much to celebrate in the first decade of the twentieth century.

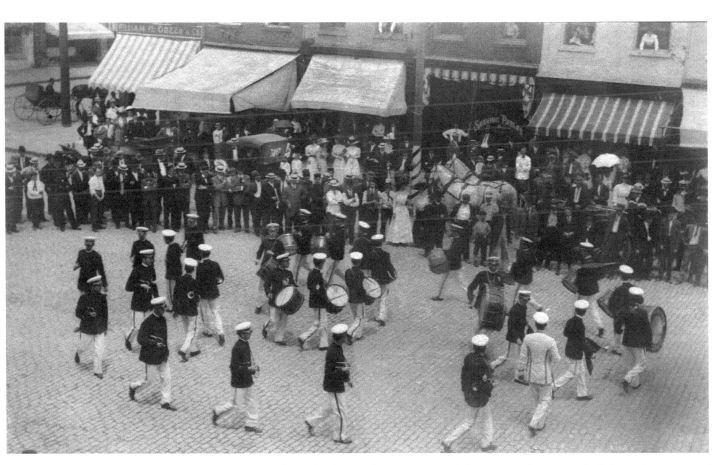

A Wilmington band displays its fancy marching skills on Front Street. Amid all that noise, a team of horses in front of the Shaving Parlor waits quietly, unperturbed.

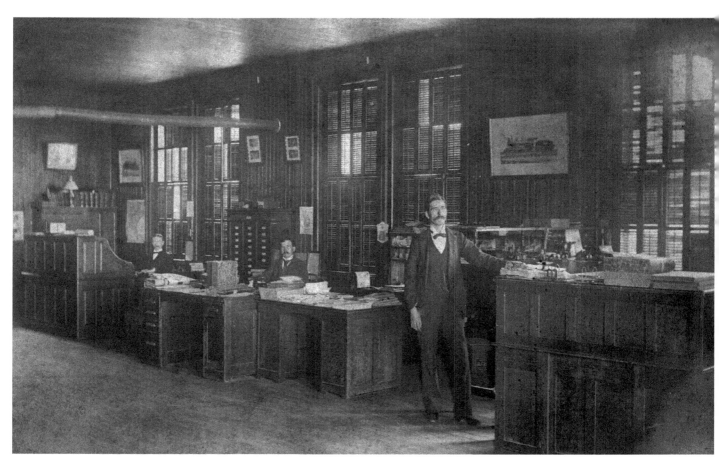

Andrew J. Howell stands in the office of the Wilmington, New Bern, and Norfolk Railroad in Wilmington in 1907. Meant to fill a short-haul niche, the railroad faced competition with the developing rail corporations as well as a short-haul trucking industry that would be blooming by the early 1920s.

Hanover Iron Works opened in 1903 at 111 Water Street. The company specialized in sheet metal work. Here in 1908, employees seem to be making a diligent effort not to pose for the photographer. In recent times, the business has expanded and improved, and the company is still located in Wilmington.

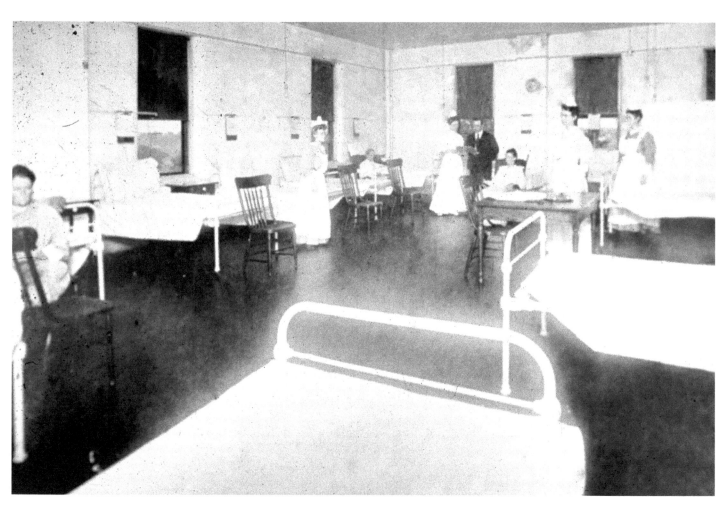

The Women's Ward at James Walker Memorial Hospital appears less than full on this day in 1909, but well staffed with nurses.

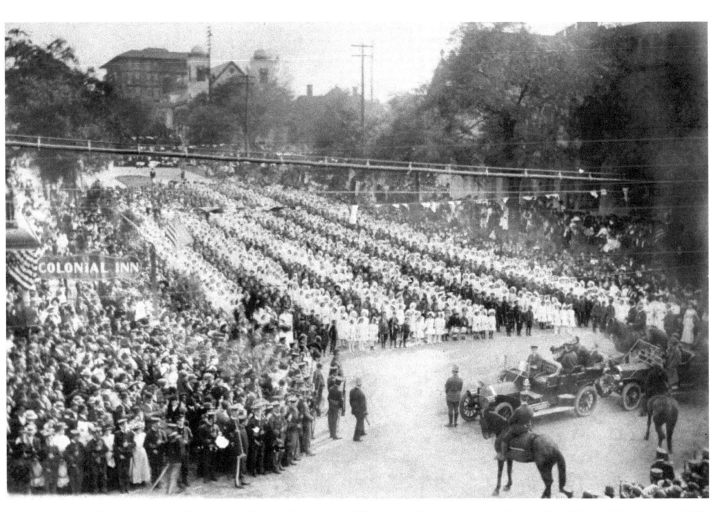

Perhaps the proudest moment in the first decade of the twentieth century arrived for the Port City on November 9, 1909, when President William H. Taft visited Wilmington. Before he spoke, he recognized the children of Wilmington at Third and Market streets, where they had assembled in the shape of a huge American flag.

Horace King, Sr., holds his daughter on a motorcycle outside the Motorcycle Shop at 132 Market Street around 1909. Two of the other motorcyclists are preparing to leave for Philadelphia. Since their introduction in 1894, motorcycles had seduced many a lad in Wilmington (and more than a few lasses).

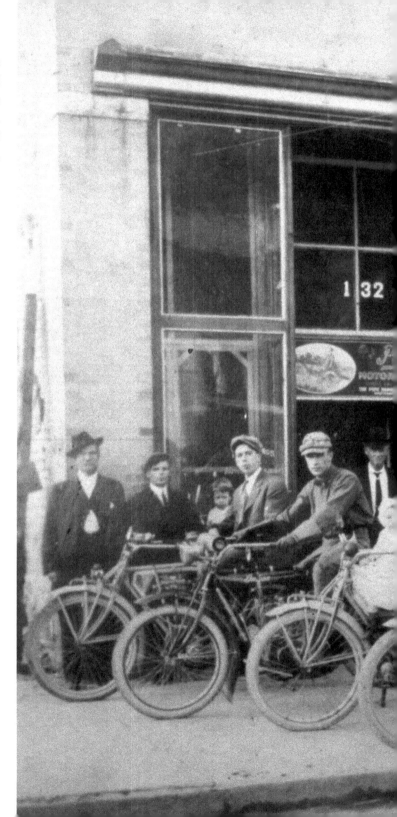

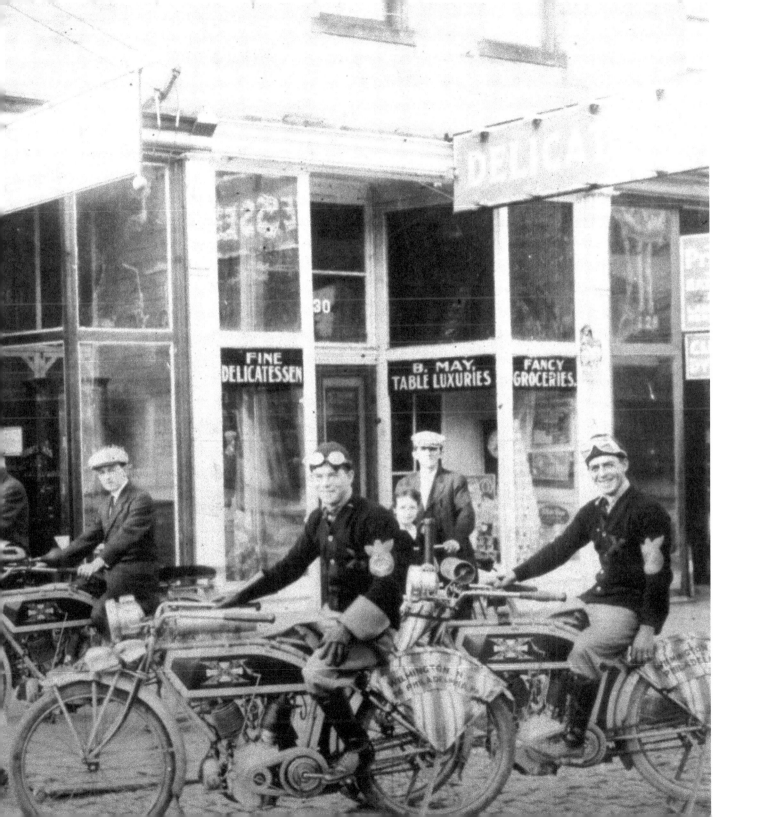

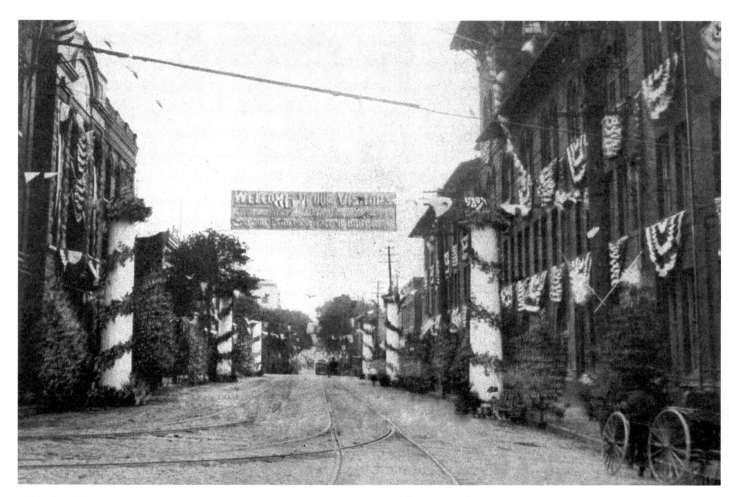

With the Wilmington Light Infantry as a special bodyguard, President Taft followed the decorated parade route (Front and Red Cross streets, with Front Street shown here) to City Hall. More than 15,000 people lined the parade route or packed the streets around the steps of City Hall to hear his speech. Before leaving, the president took a brief cruise along the Cape Fear on the revenue cutter *Seminole*.

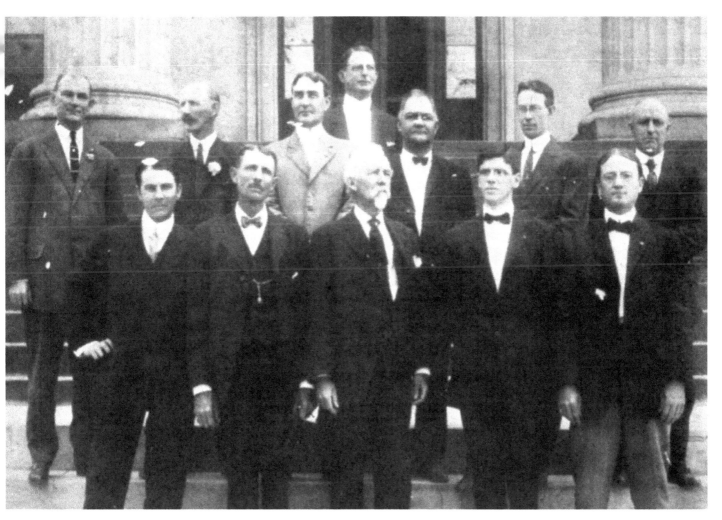

When the city of Wilmington Board of Aldermen posed in 1909 on the steps of City Hall for this picture, they could be proud of the job they had done to bring the Port City into the twentieth century. With other Wilmingtonians, they looked forward to the next decade with hope for continued prosperity.

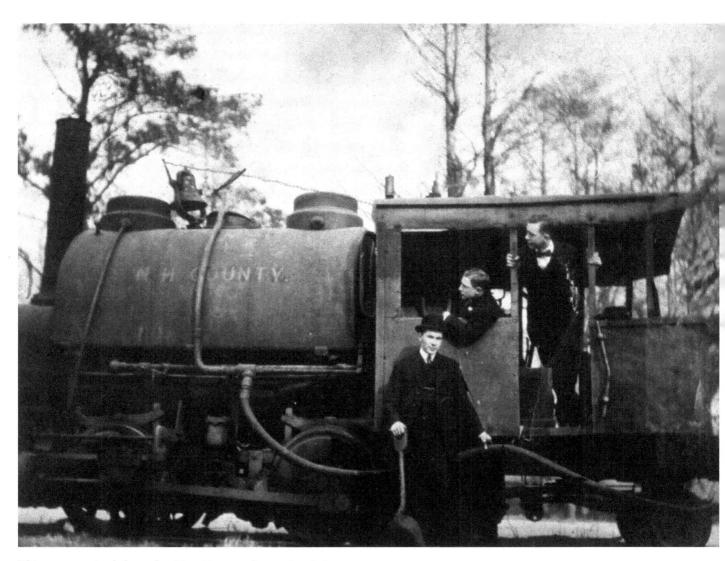

This steam engine belonged to New Hanover County in 1910.

Dedicated in 1912, St. Mary's Cathedral was funded with contributions from many of Wilmington's Catholic citizens. It was designed and constructed as the intended cathedral for the Diocese of North Carolina. In 1924, when that honor went to a smaller cathedral in Raleigh, some residents felt betrayed.

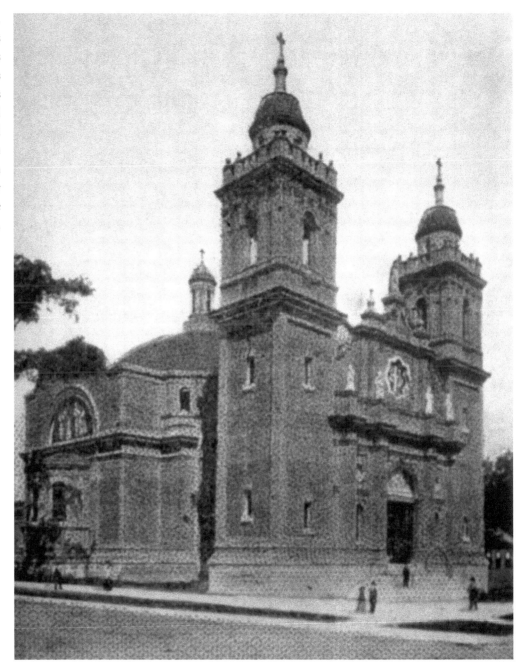

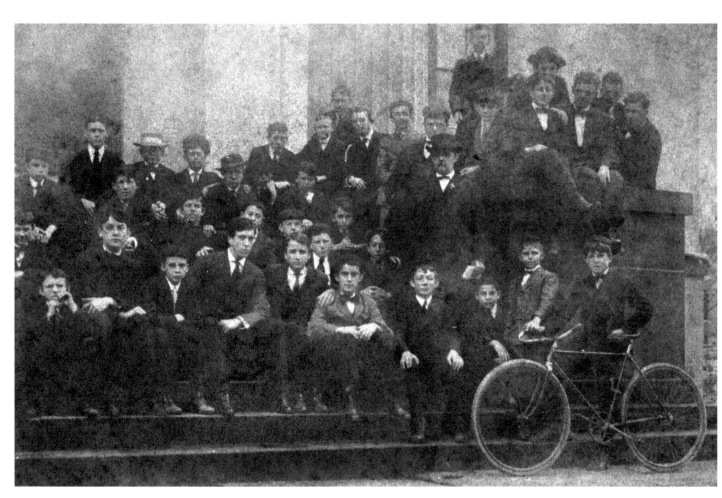

Organized in 1868 by former Confederate brigadier general Raleigh E. Colston, Cape Fear Military Academy served several generations in the Port City. Initially, the young men at this preparatory school wore uniforms and drilled daily. This picture, recorded sometime between 1910 and 1915 on the steps of City Hall, reveals that the school's military codes had been relaxed. Professor Washington Cattlett led the school in these later years.

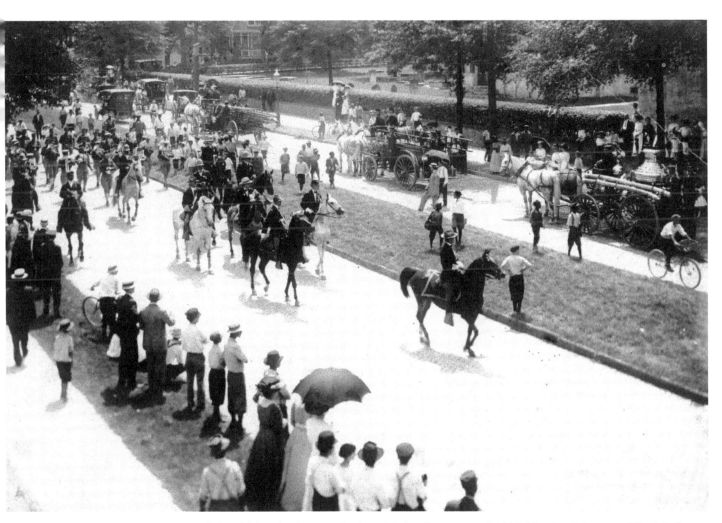

Colonel Metts leads a parade along Market Street around 1910. Newfangled automobiles join horse-drawn fire wagons, the one at upper-right sporting a steam pump, for the march.

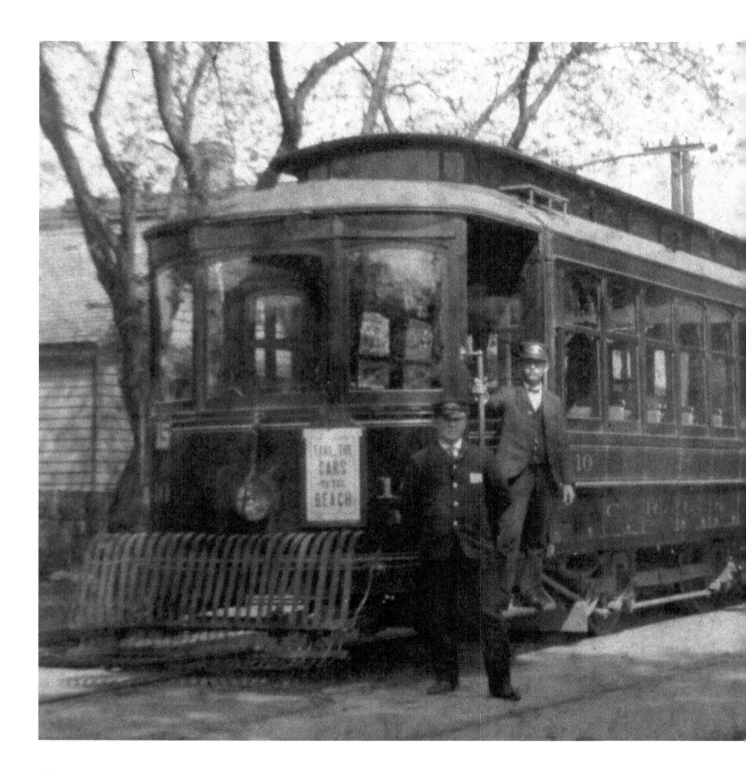

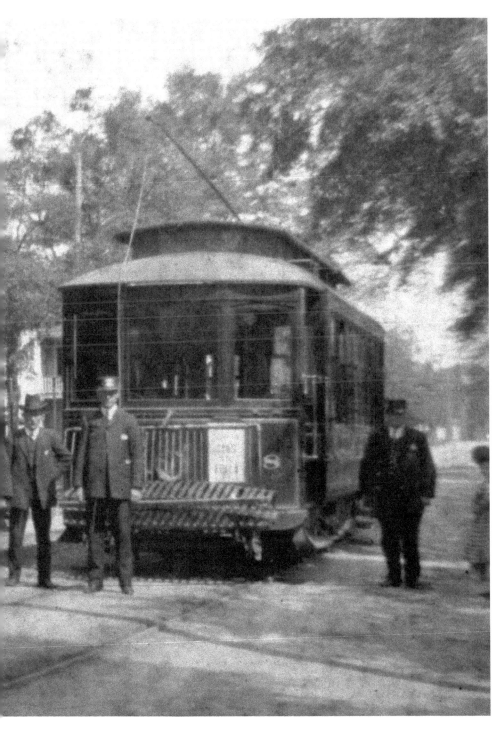

Displaying ads that read "Take the cars to the beach," city streetcars prepare to start the day around 1911.

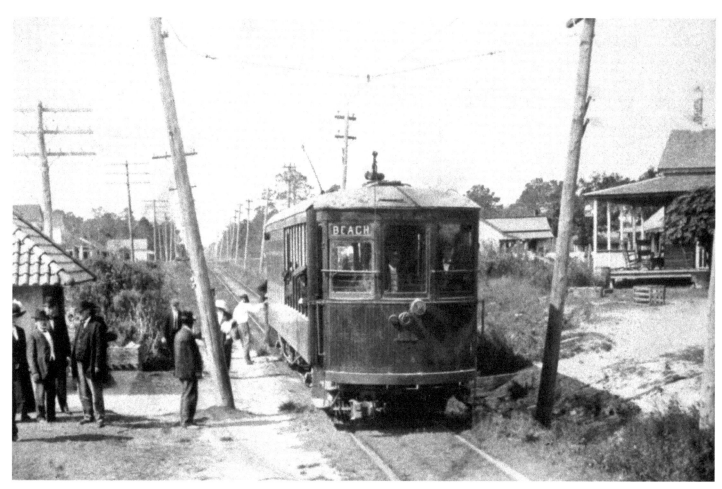

All aboard! A Beach Electric Line trolley stops at Seagate Station in the early 1910s.

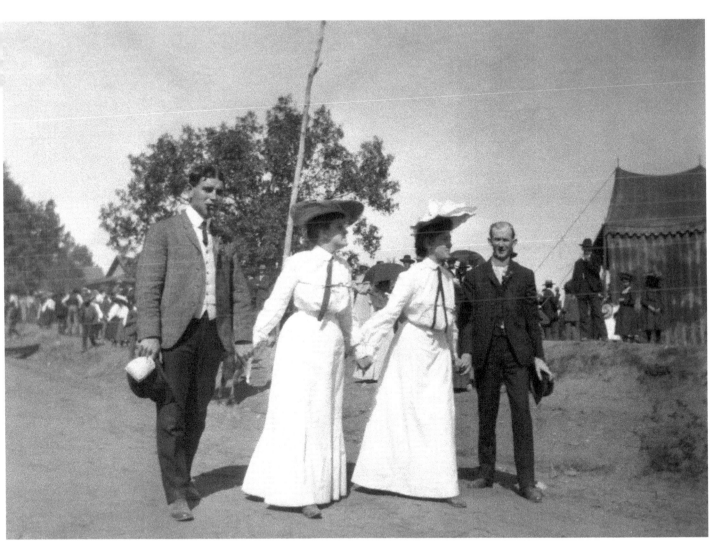

Young and old alike love the circus, as proven by these well-dressed ladies and their escorts
sometime around 1910.

A well-trained baboon, doing a great imitation of anyone's favorite politician, seeks to separate circus-goers from their cash. The annual visit by the "Circus Train" and the parade from the train station to an empty local field inevitably drew crowds to the "Big Top."

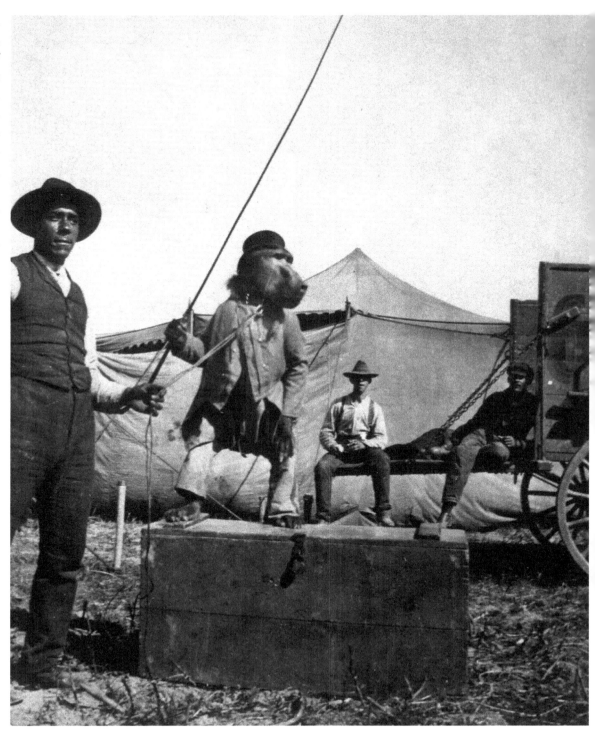

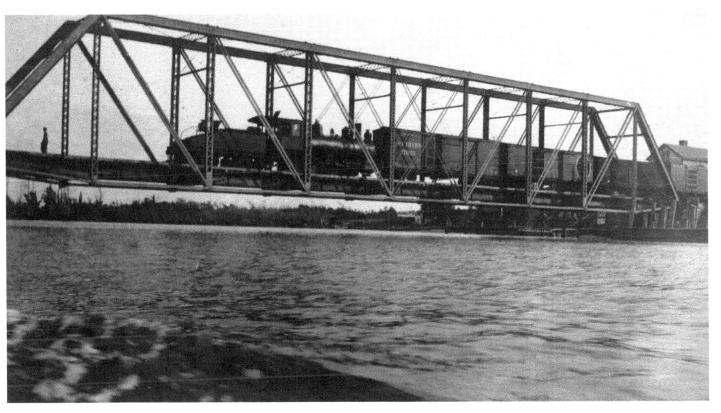

An engine pushes cars across the Hilton Railroad Bridge around 1910.

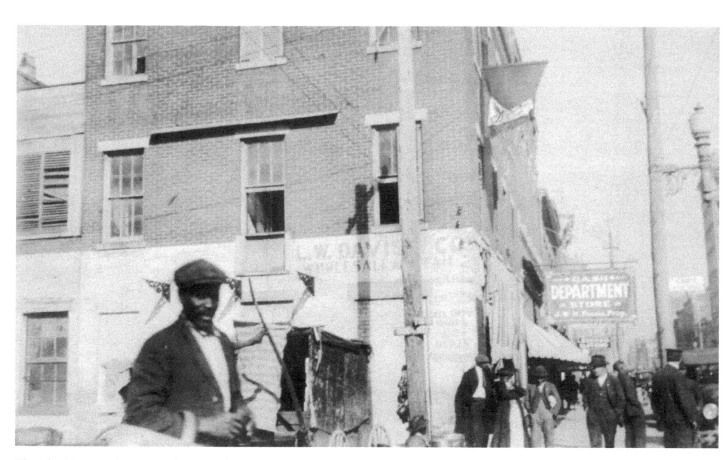

These buildings at the corner of Dock and Front streets, around 1911, could use some repair, especially the L.W. Davis Wholesale Company. Beyond the corner on Front Street is the Cash Department Store. A police officer idles alertly on the corner.

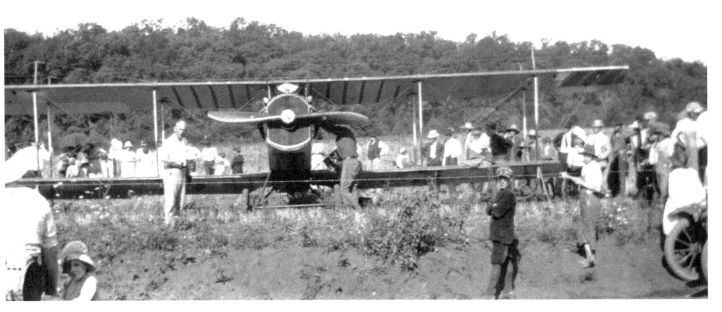

Sometime around 1912, airplanes made an appearance in Wilmington, though it would be 1927 before the Port City built an airport (Bluethenthal Airport) to supplement its rail and river infrastructure. Shown here, a biplane takes advantage of an empty field to enthrall onlookers.

Sometime around 1914, Mrs. Stephen Provost prepares for a ride on this biplane belonging to Berger Aviation Company. Whether she actually flew is not recorded.

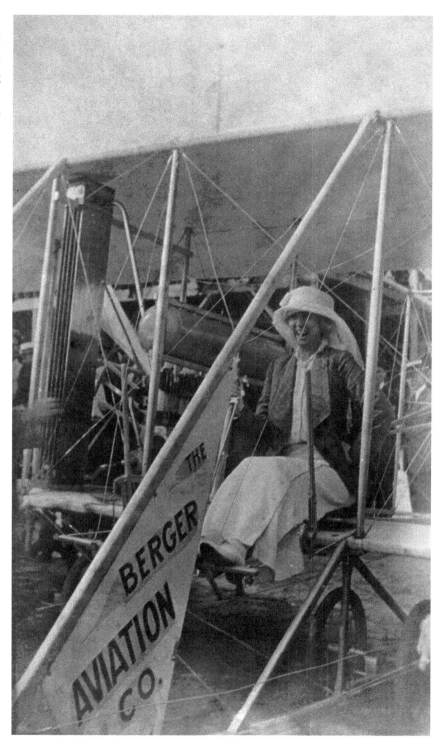

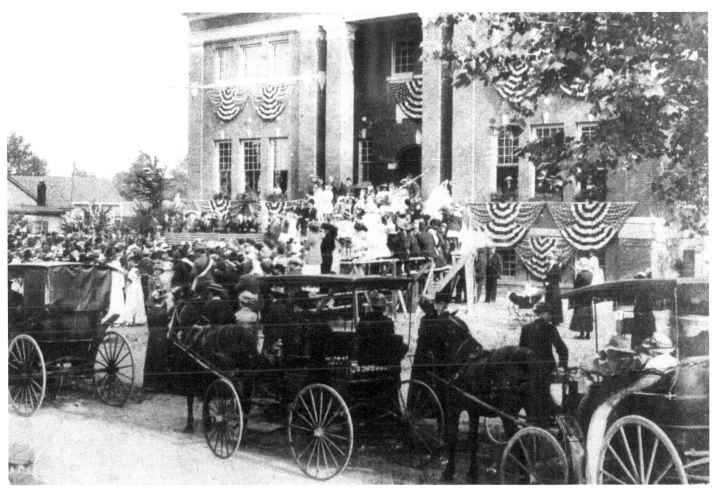

A crowd gathers in 1912 to dedicate Isaac Bear School, located on Market Street near the intersection with Thirteenth Street. Little could they guess that 35 years later the building would become home to newly founded Wilmington College.

The J. W. H. Fuchs
Department Store operated
at Front and Dock streets for
several years. This photograph
dates to 1911 or 1912.

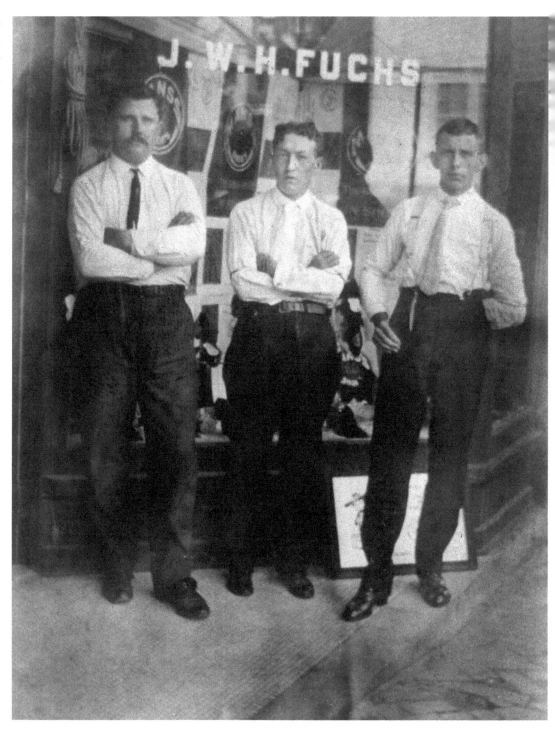

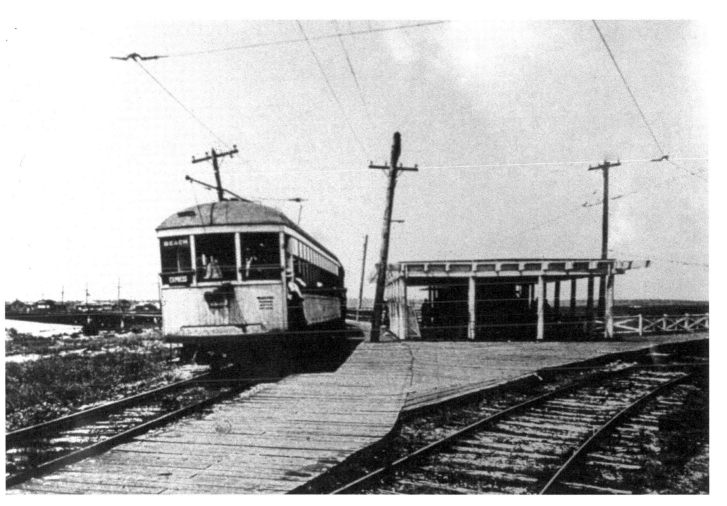

The opening of electric trolley service to Wrightsville Beach in 1902 not only eased the trip to ocean waters, it enabled people to live on the banks while working in Wilmington. The trolley made possible one of the first modern suburbs in North Carolina. This is an image of Station 1 at Wrightsville Beach. The tracks at left lead to the Lumina Pavilion—and lots of fun!

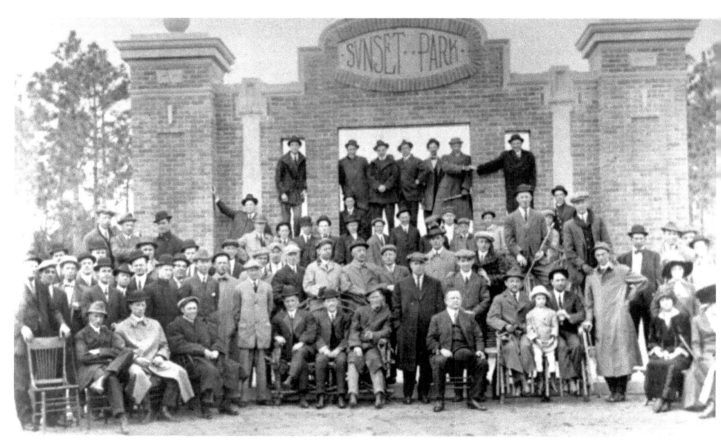

In 1913, the Baltimore Orioles held spring training in Fayetteville. The Philadelphia Nationals, also training in North Carolina, scheduled a number of exhibition games with the Orioles, including one in Wilmington on March 22. This picture, recorded on March 20 at Sunset Park, is part of the welcoming ceremony extended by the Port City.

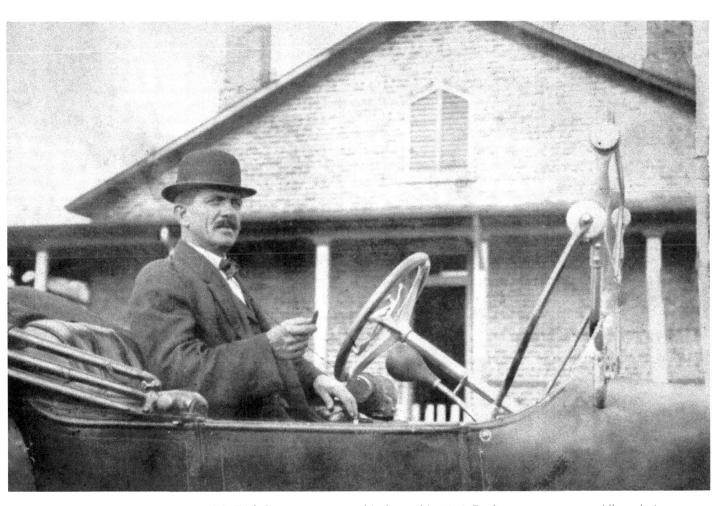

Mr. Dick Burnett prepares to hit the road in 1913. By that year, cars were rapidly replacing wagons on the streets of Wilmington. Their popularity led to road paving and, in the 1920s, to the bridging of the Cape Fear River.

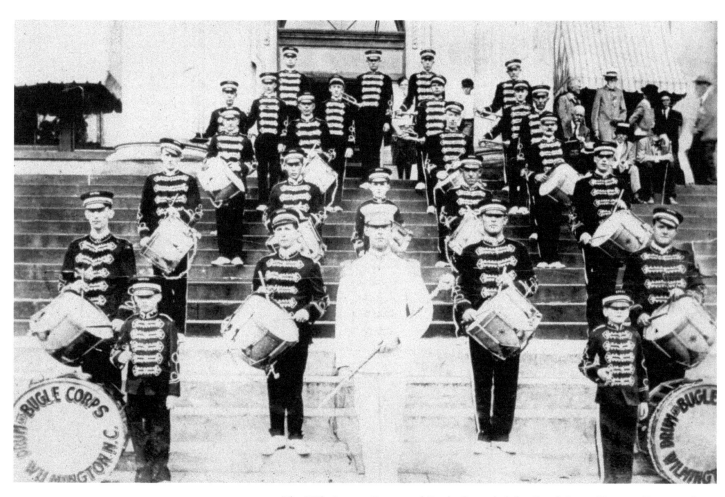

The Wilmington Drum and Bugle Corps led the Confederate Veterans Day parade on Robert E. Lee's birthday, January 19, 1914.

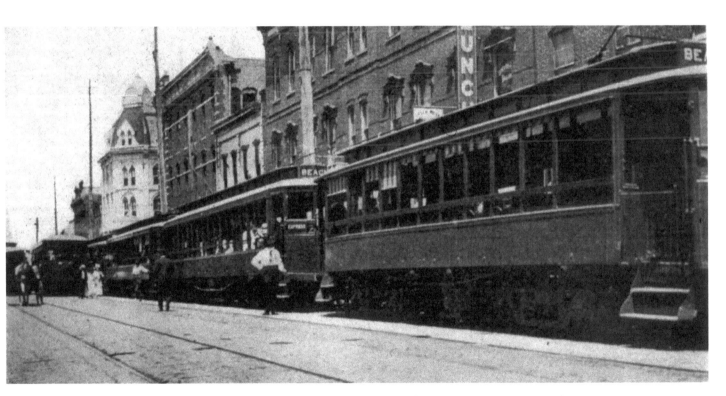

Wilmington trolleys that traveled to Wrightsville Beach were known as the "Beach Cars." Each year, as warm days marked the end of another Carolina winter, Tide Water Power Company increased the number of cars in service on the line. Beach Cars are shown here leaving Front and Princess streets in the mid-1910s.

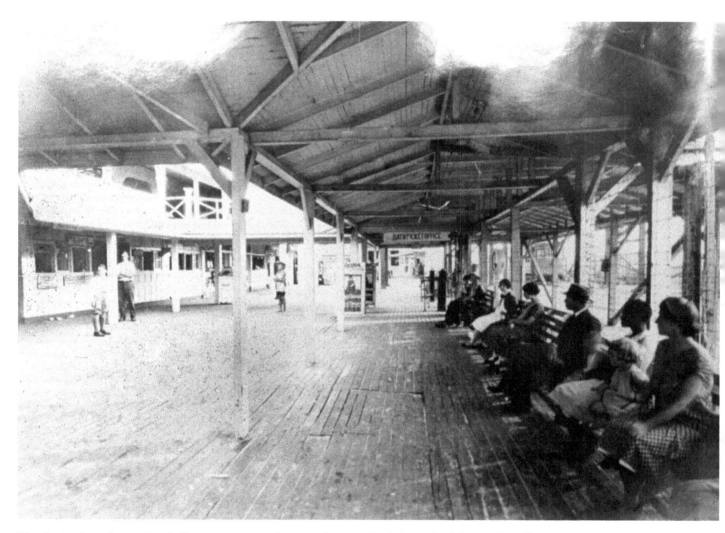

The destination of many Beach Car passengers was Lumina, Station 7 (and the end) of the Wrightsville Beach Line. Lumina Pavilion (opened in 1905 and used until its demolition in 1973) provided dancing, bathing, movies, and games for several generations of area residents. Worn out from all the fun, these people await the trolley at Lumina Station.

As the air over France began to capture the attention of the world, interest increased in flying machines and the "Knights of the Air" flying them in combat. On this day around 1915, Nurnberger's Meat Market likely got less attention than the biplane parked in front of it.

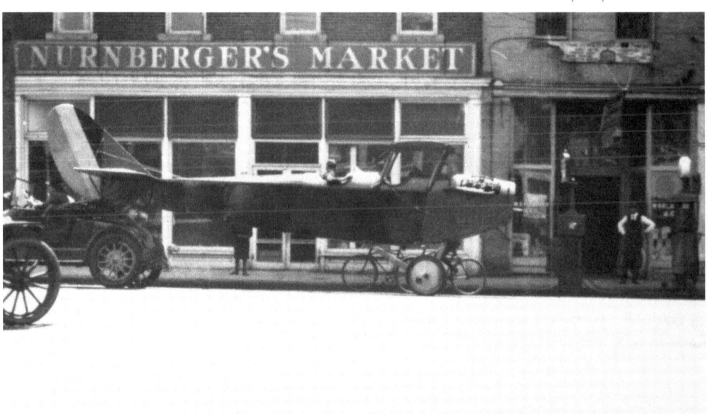

Baseball dominated sports in the early 1900s, and Wilmington did not differ from cities nationwide. As the pennant proclaims, these gentlemen claimed the Port City's championship in 1914.

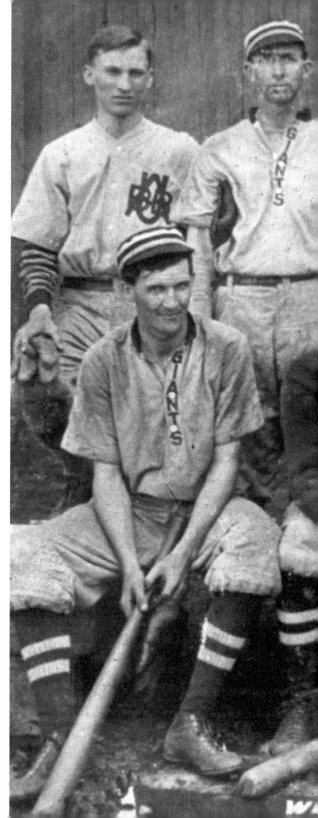

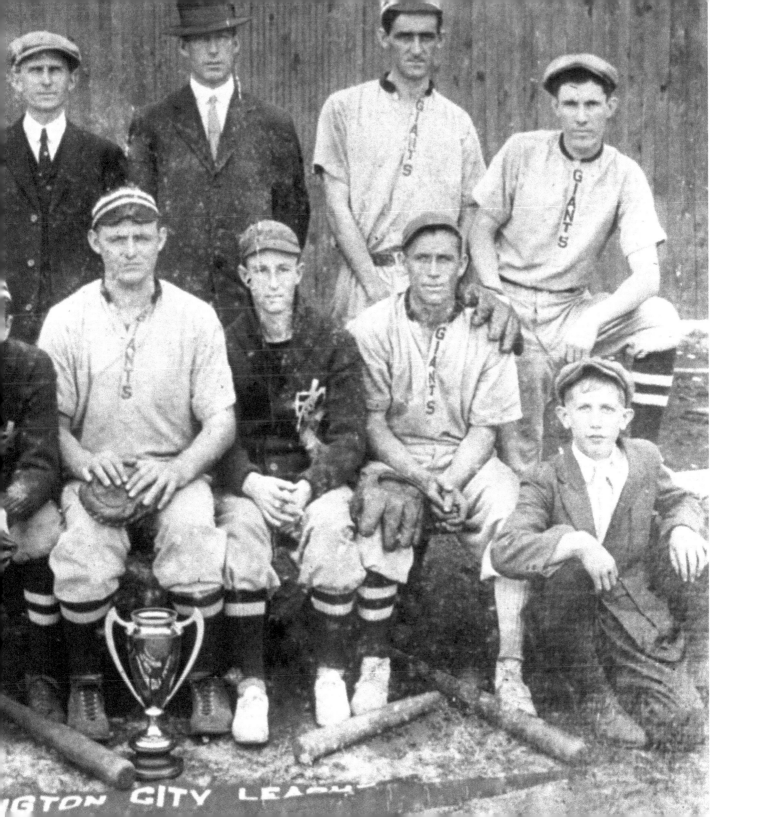

IGTON CITY LEAG

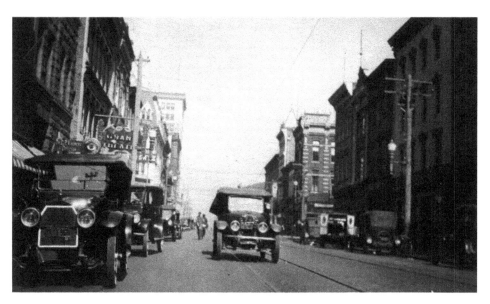

A car bounces across the trolley tracks around 1915 on a Front Street crowded
with automotive traffic, including delivery trucks. The Grand Theater, on the left,
operated from 1913 to 1923, and housed various retail establishments thereafter.
The theater and the Masonic Building to its left still stand today.

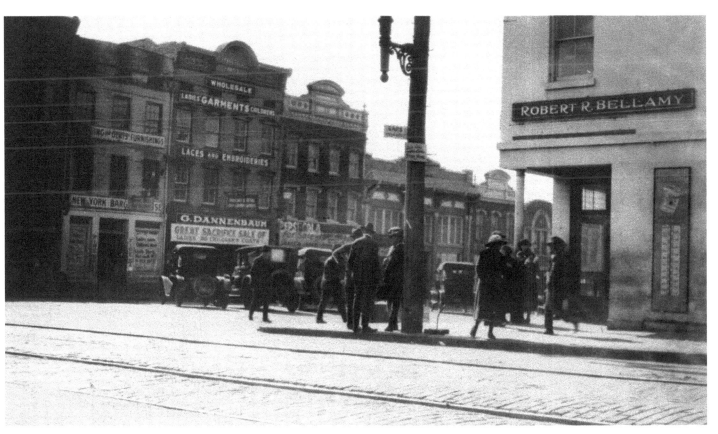

Customers shop at the corner of Market and Front streets around 1915. The pharmacy operated by Robert R. Bellamy (right), established in 1885, continued in business until 1930. G. Dannenbaum's Store for Women (across the street), despite its "Great Sacrifice Sale," also continued operations into the 1930s.

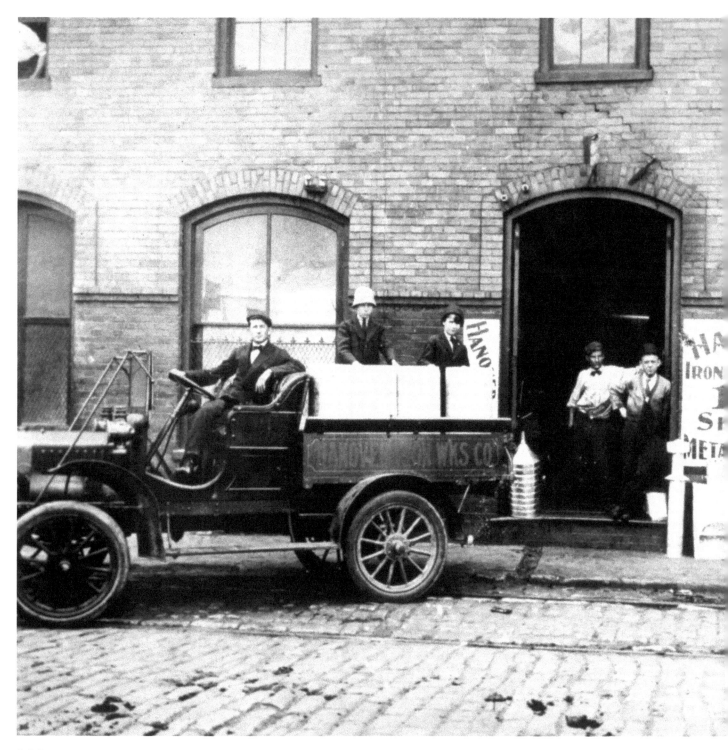

Hanover Iron Works occupied this building on Water Street around 1915. The youngsters in the delivery truck are rough-and-ready for a bumpy ride along the cobbled pavement.

In 1915, workmen demolished the old Customs House (dating from 1843) and adjacent buildings on Water Street to make room for a larger building. Completed in 1916, the United States Customs House is better known today as the Federal Building.

From its opening in 1901, the James Walker Memorial Hospital practiced teaching as well as healing. Dr. Herbert Codington, Sr., poses with a group of interns here in 1916. It is highly probable that some of these young men would see the results of the trench warfare then raging in Europe within the next two years.

Part of the congregation gathered on the steps of First Baptist Church in 1916. It was a good time for solemn faces and heartfelt prayer, as only a year remained before the United States—and Wilmington—entered the Great War.

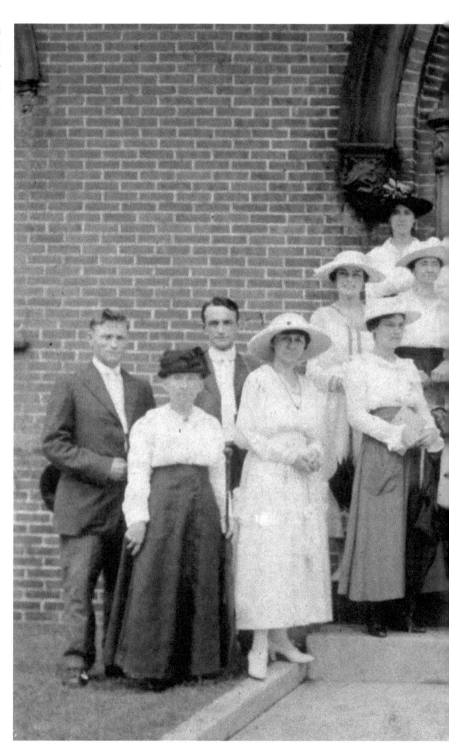

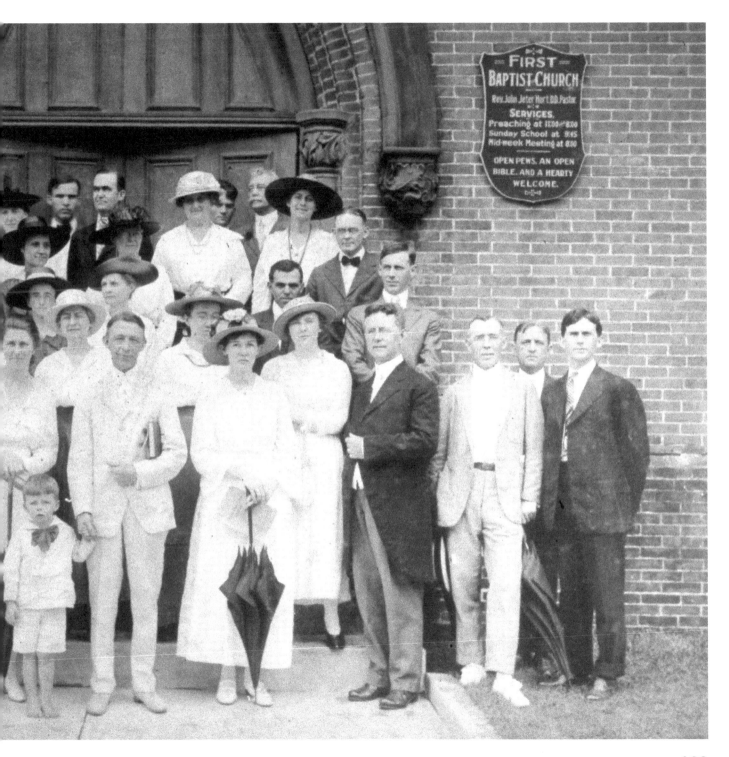

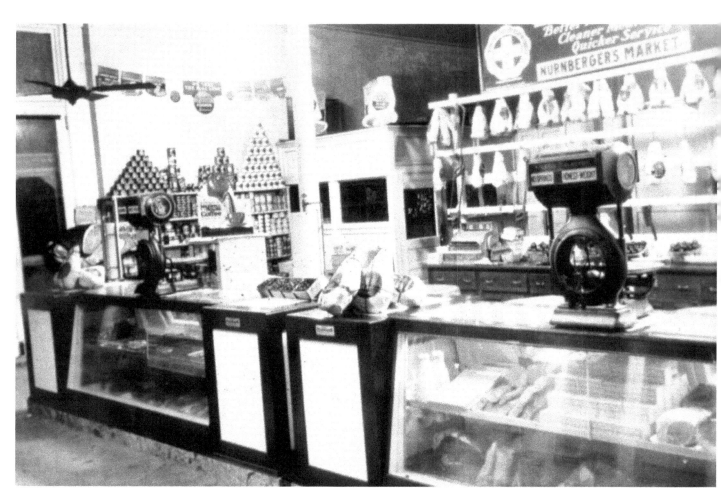

This is a view of the interior of Nurnberger Meat Market (Second and Market streets) in early 1917.

From Great War to Great Depression

(1917–1929)

World War I, or the Great War (and for a misguided while, the War to End All Wars) as it was called in those days, offered no interruption to Wilmington's growing prosperity. Though individual families paid a price as loved ones left for war and failed to return, the city and New Hanover County as a whole benefitted through shipping and shipbuilding. Wilmington also took great pride in the fact that the man who led the United States through the war, President Woodrow Wilson, was an adopted son of the city, his father having served as a minister in Wilmington for eight years.

Though little new industry appeared in the county during the 1920s, Wilmington continued to earn its "Port City" nickname. Five convergent rail systems and, in 1929, a road link completed by causeway and bridge across the Cape Fear River meant a constant flow of goods across Wilmington's docks. In 1927, the city embraced the newest mode of transportation when it completed Bluethenthal Airfield.

If Wilmington embraced anything resembling new industry during those years, it was tourism. From Wrightsville Beach to Carolina Beach, new hotels seemed to erupt from the very sands; and at Wrightsville Beach, Lumina Pavilion became a story in its own right. By rail, by car, and (eventually) by air came tourists from all parts of the country drawn to warm temperatures, beautiful beaches (on both sea and sound), good entertainment, and southern hospitality. The fact that the waters around Wilmington teemed with booze smugglers, most of them apparently successful, probably did nothing to hurt tourism during Prohibition.

Tourism offset monetary losses as the American economy weakened after 1925. To continue attracting tourists, the city spent money on improvements—sidewalks, roads, bridges, airports, and even yearly celebrations. By 1929, Wilmington (like most American cities and too many private citizens) was in debt. In 1930, the celebrations screeched to a halt.

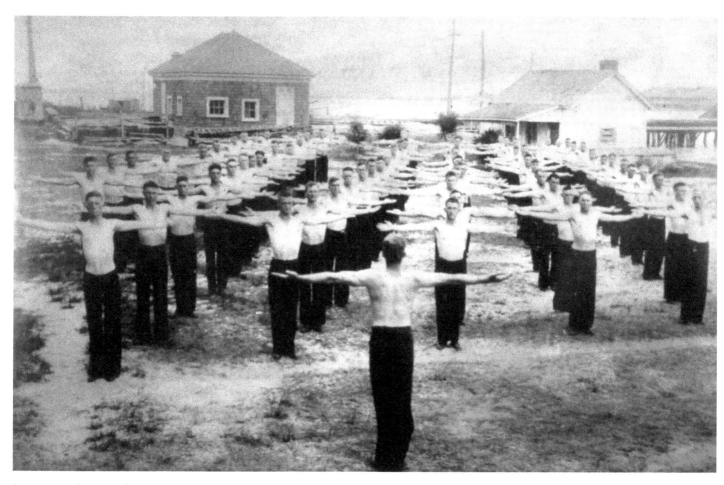

In 1917, as the United States entered the Great War, the U.S. Navy established a training command at Hammocks, near Wilmington. Existing structures, such as the Baptist Seaside Assembly Building, housed sailors, equipment, and command staff.

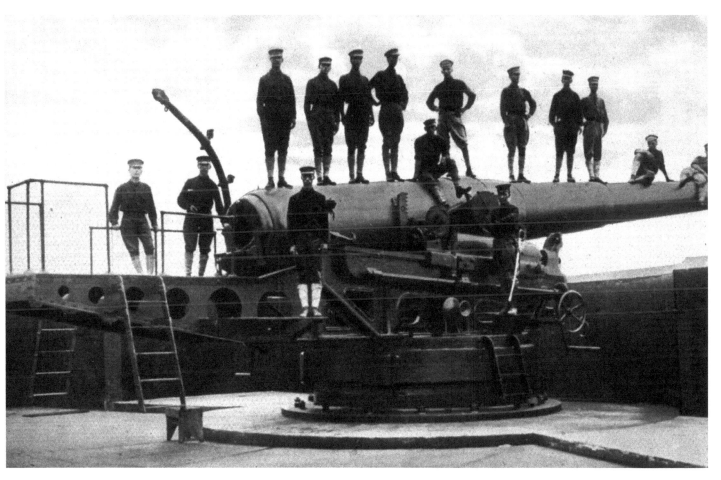

Though little chance of invasion existed for North Carolina, ports such as Wilmington stationed their share of defenses. Officers and crew of a 12-inch gun mounted at Fort Caswell pose for the camera in 1918, waiting patiently for the German raiders who never came.

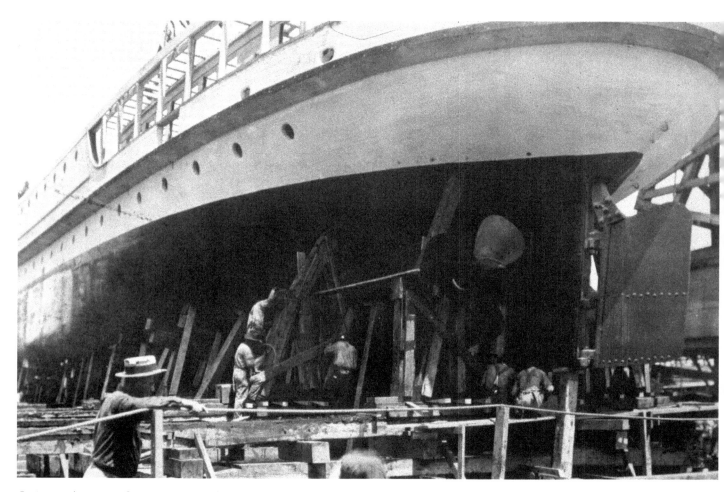

Owing to shortages of steel in 1917, orders were placed for more than thirty "Concrete Cargo Ships"—vessels with five inches of concrete added to their hulls. Shipyards, such as the Liberty Shipyard at the foot of Greenfield Street (shown here in 1918), managed to complete only a dozen of those vessels. All proved less than adequate while at sea.

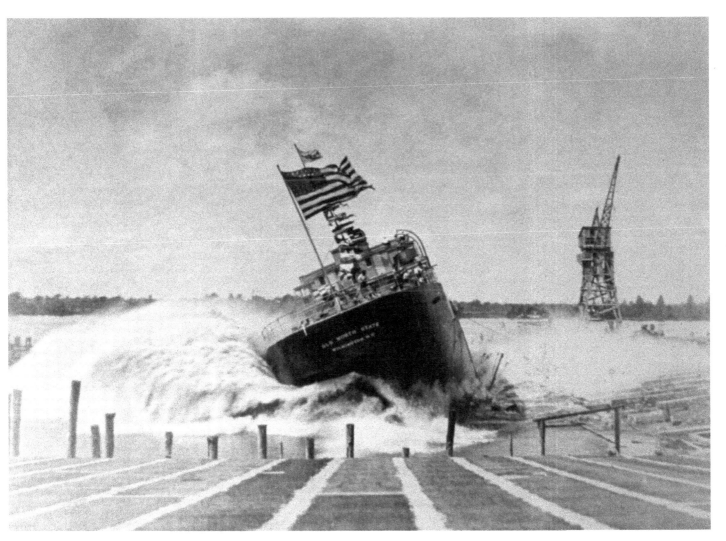

Liberty Shipyard managed to launch a concrete ship in 1919, too late to support the war effort but on time to return soldiers to the United States.

Motorized ambulances appeared at James Walker Memorial Hospital around 1919.

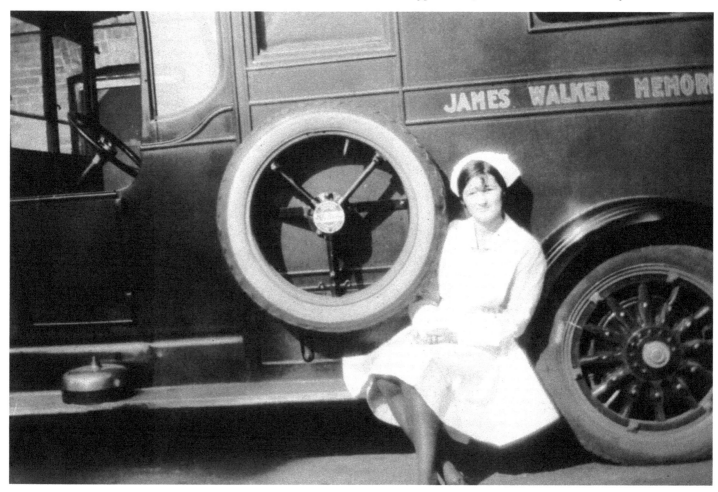

Without today's emergency medical technicians and too few doctors to send with ambulances, nurses carried the burden of onsite care and rescue. Four nurses and the driver pose beside a new ambulance around 1919.

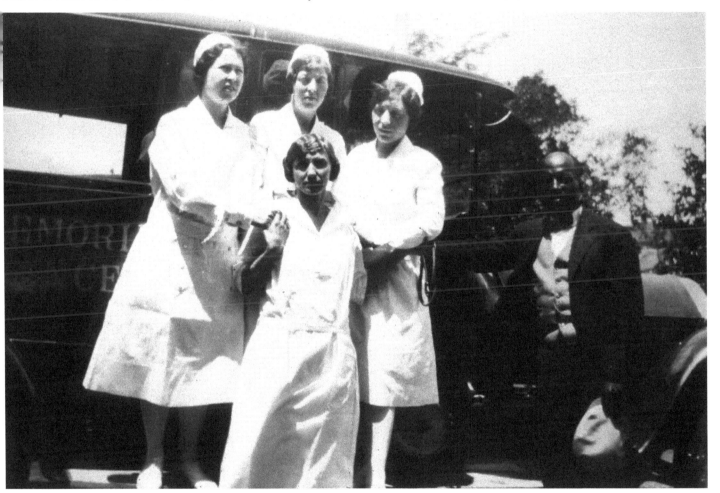

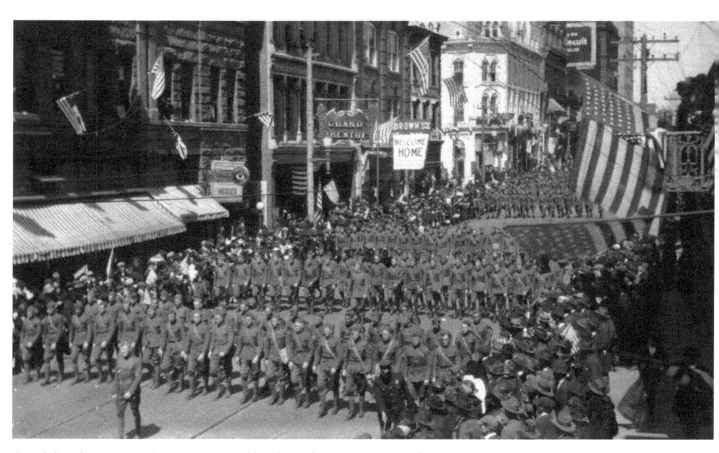

Crowds line the street to welcome American soldiers home from Europe on March 30, 1919. The lead marchers are passing the Masonic Building on Front Street, with the Grand Theater just beyond.

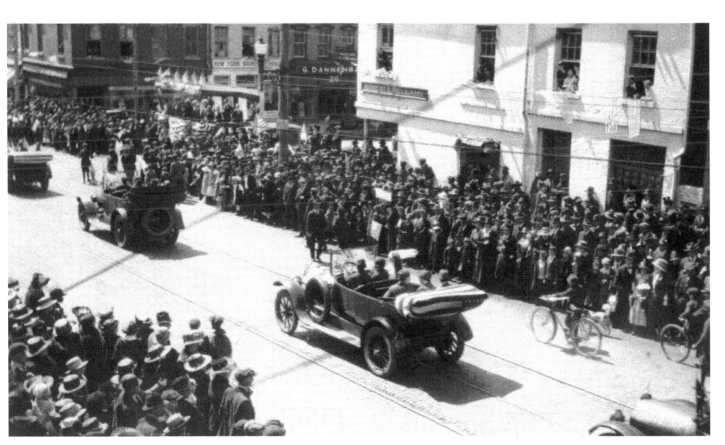

Officers and civilians follow the marching troops as they pass Bellamy's Pharmacy on Front Street.

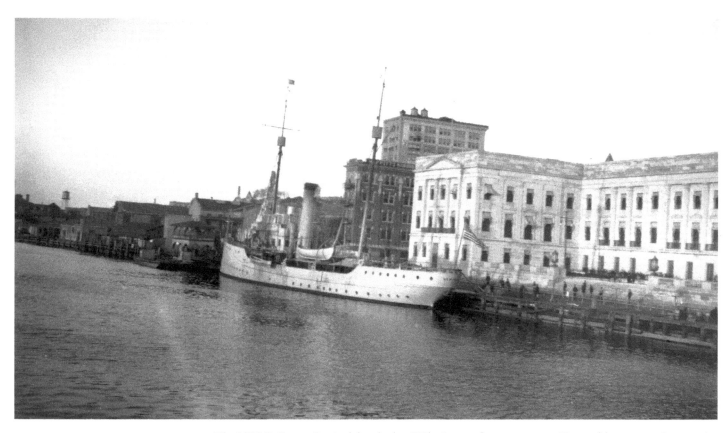

The USCG Cutter *Seminole* berthed at Wilmington for many years. Pictured here around 1919, she is moored in front of the Customs Building. It was from here that the cutter sailed in January 1921 to become a part of the mystery of the *Carroll A. Deering*, a ship that ran aground in North Carolina with no trace of its crew.

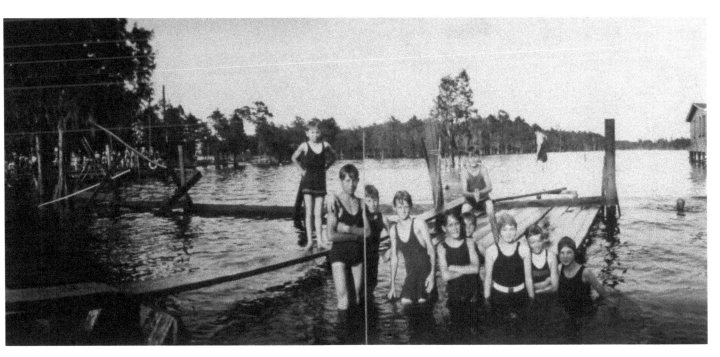

A popular swimming spot for years, the city purchased Greenfield's and McIlhenny's Mill pond in 1928 (some ten years after this photograph). During the Great Depression, WPA workers dug drainage ditches and constructed the five-mile-long Community Drive around the site, turning it into the lovely Greenfield Park that many Wilmingtonians to follow would enjoy in youth.

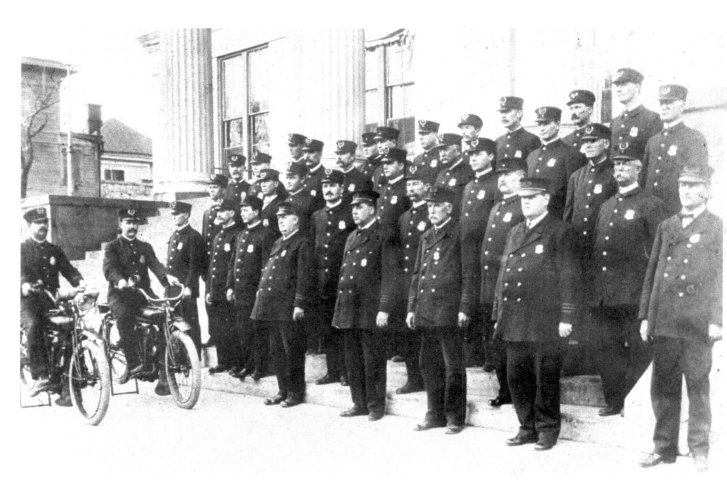

The Wilmington Police Department, including its motorcycle troop, snapped to attention on the steps of City Hall for this photograph in 1918.

In May 1918, a Beach Car overturned on the Wrightsville Beach route. No serious injuries resulted from the accident. Eventually, these and other workers managed to pull it from the marsh and restore it to service.

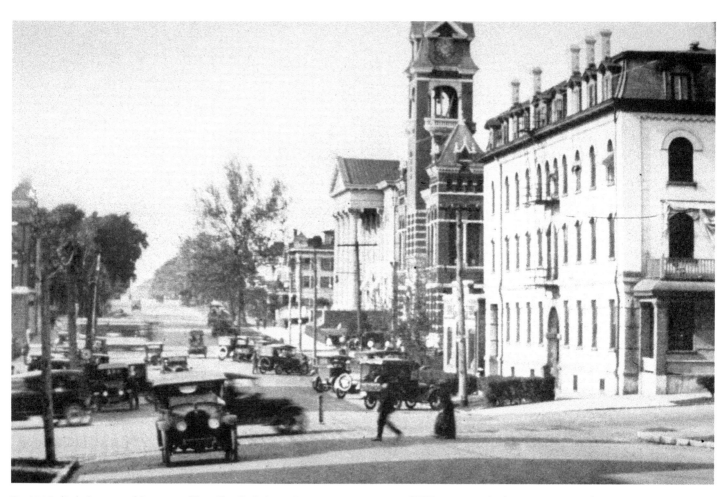

By 1919, little horse-and-buggy traffic still rolled along the prosperous streets of Wilmington. At the intersection of Third and Market streets, however, other traffic (unregulated by sign or light) seemed heavy.

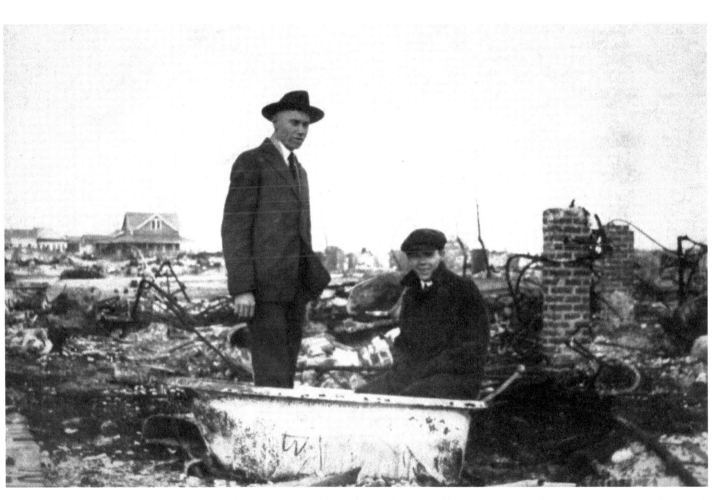

Built in 1897 (and expanded thereafter), the Seashore Hotel had 180 rooms, a large pavilion, men's and women's bathhouses, and a steel pier jutting into the Atlantic. On June 26, 1919, 400 guests fled a fire that consumed everything except the steel pier. Even the pier collapsed soon afterward, a victim of winter storms in 1920 and 1921.

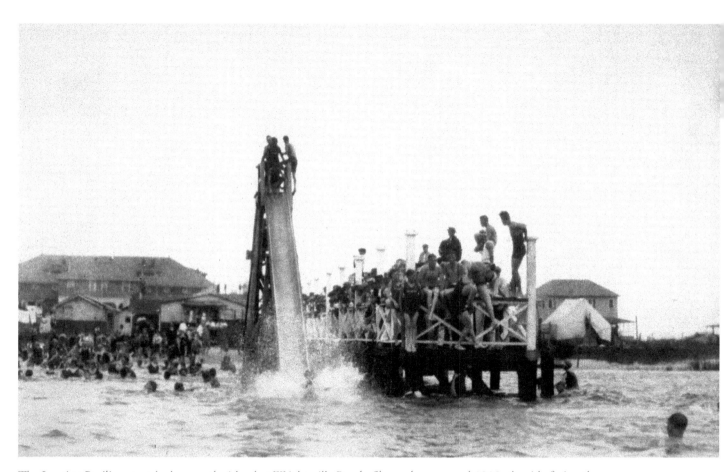

The Lumina Pavilion stretched across the island at Wrightsville Beach. Shown here around 1919, the side facing the sound was especially popular, featuring a pier, water-sliding board, and swimming area.

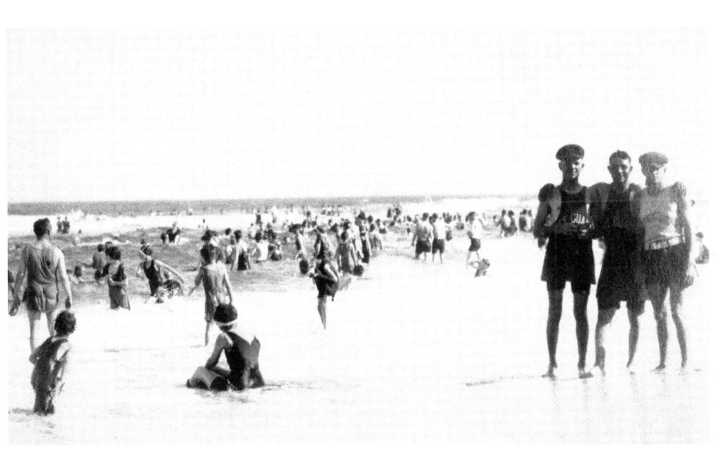

The Atlantic side of Lumina may have been even more popular than the sound side.

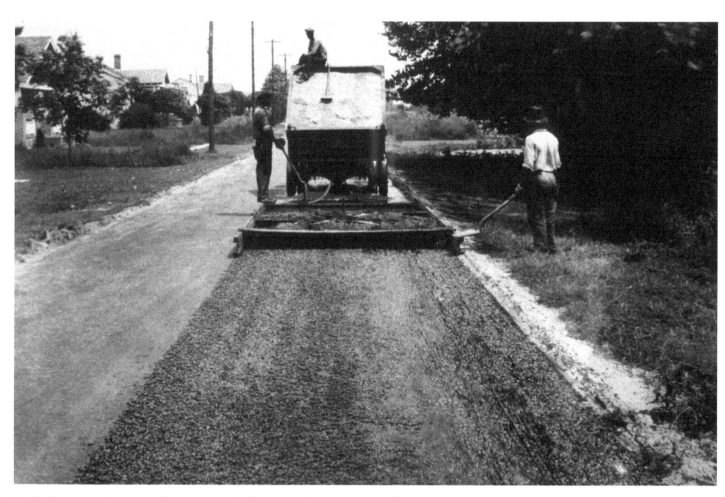

In the late 1910s, the county began tarring local roads with a process devised by Dick Burnett, Superintendent of County Road Construction. Car owners loved the idea, until heavy rain and traffic began to take their toll, creating potholes.

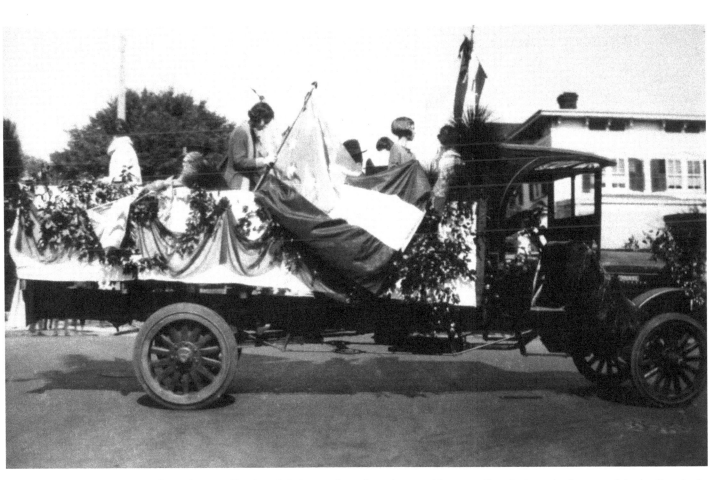

People in the Port City loved their parades, a love that would eventually culminate in the annual Azalea Parade. In this image, a truck has been converted into an impromptu float sometime in the late 1910s.

A view west along Market Street from Fourth Street in the late 1910s features (right to left) Dr. Cranmer's house, the YMCA (with the white horizontal stripes), the deRosset House, and the Potter House.

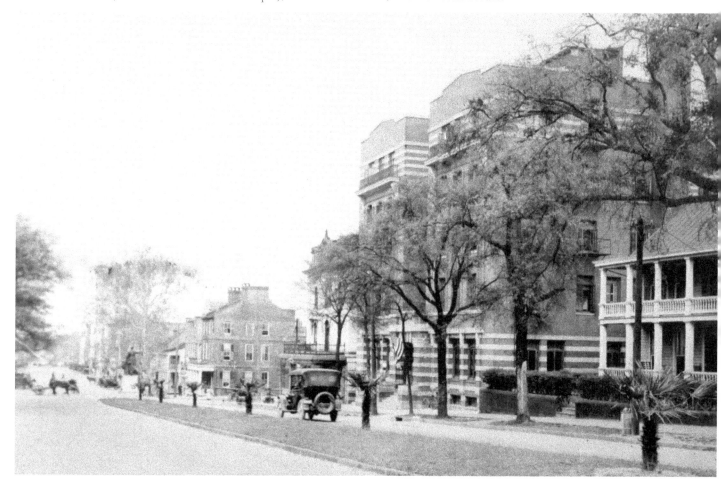

Shown here in the late 1910s, Walter Winter's fishing shack at Fort Fisher, like most of the original seaward portion of Fort Fisher, fell victim to erosion many years ago. Efforts to stabilize erosion at the state park continue to this day.

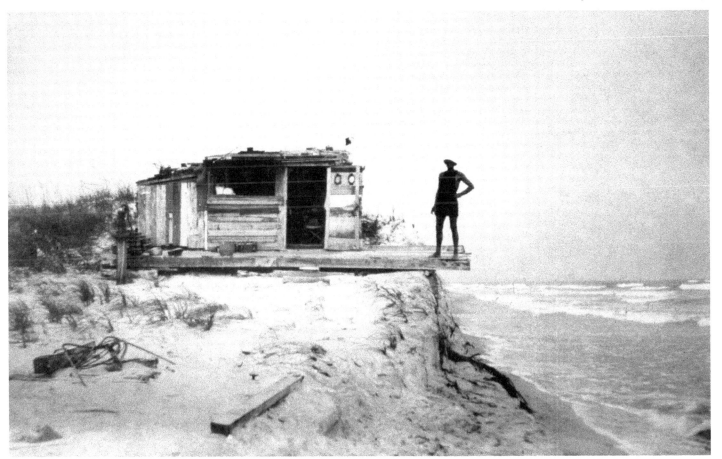

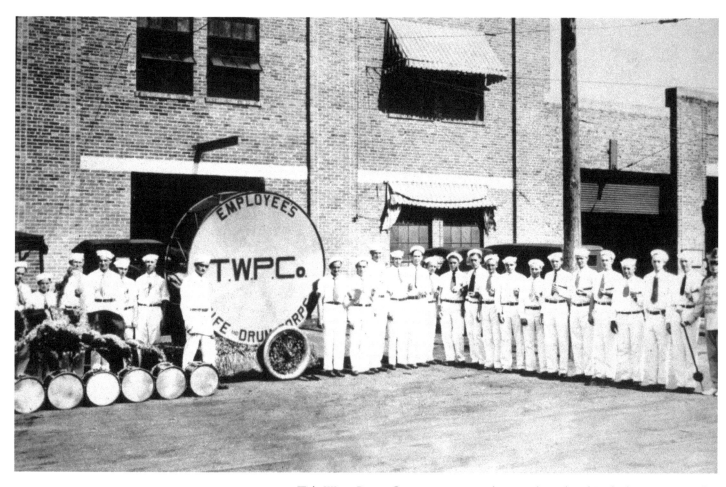

Tide Water Power Company sponsored an employee band in the late 1910s. In this picture, Bert Kite is the director.

Dr. James Buren Sidbury opened Babies Hospital in 1920 on Wrightsville Avenue near the sound. Specializing in pediatrics, Dr. Sidbury served the community until his death in 1967.

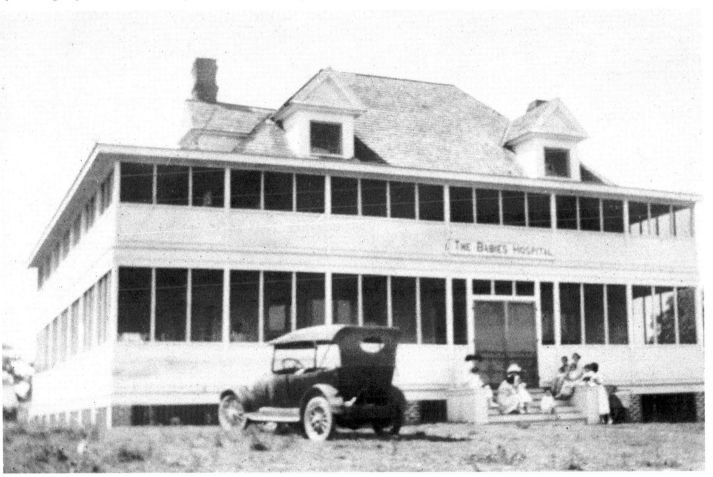

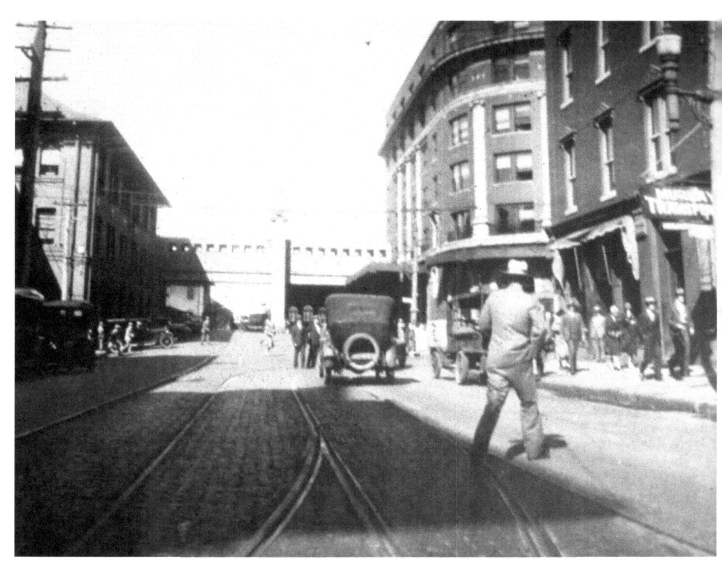

In 1920, the Atlantic Coast Line terminal made the intersection of Front and Red Cross streets a busy place. On the near right is the Atlantic Hotel, built in the early 1900s and known locally as the "Railroad Hotel." Beyond the hotel is the distinctively curved facade of Union Station. Directly across the street from the station is the old Atlantic Coast Line General Office Building.

Lumina held athletic competitions three times yearly, such as this race in the early 1920s. The thin, vertical structure on the right is a movie screen. Lumina aired silent movies nightly during the summer. The surfboat at left, beneath the deck of the pavilion, was used by professional lifeguards, who trained extensively for all kinds of water rescues.

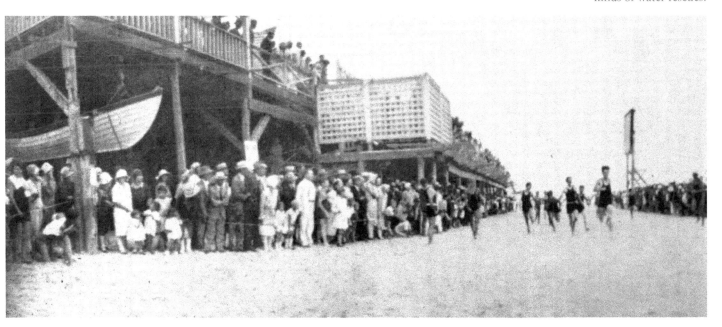

By the 1920s, the beaches near the Port City were frequented by equal numbers of tourists and locals. Small hotels, such as the Breakers Hotel at Wilmington Beach shown here in 1920, catered to a less wealthy crowd than the swank Seashore or Oceanic (former Tarrymore) hotels at Wrightsville Beach.

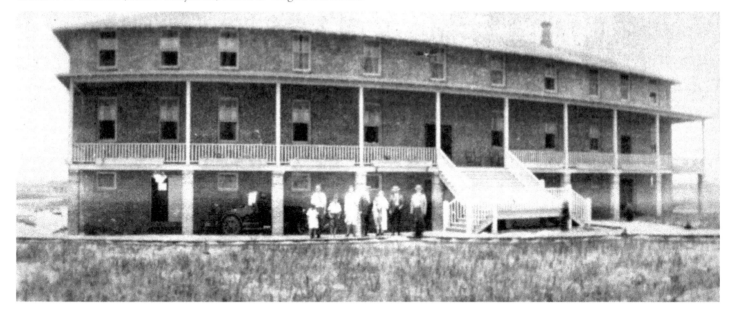

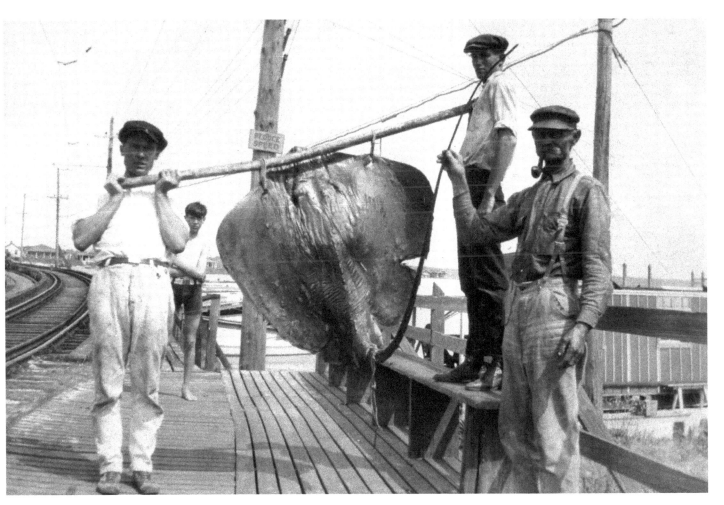

Fishermen captured this large stingray (known locally as a "sting-a-ree") at Wrightsville Sound around 1925. Ordinarily docile creatures, rays nevertheless pack a barbed, and dangerous, tail.

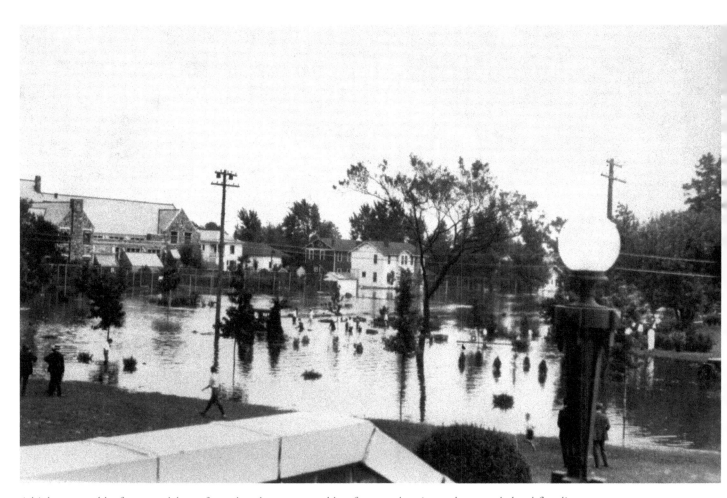

A high water-table, frequent deluges from thunderstorms, and less frequent hurricanes have made local flooding a continuing challenge for the Wilmington area. Sometime after 1922, a camera captured this flooding near Market Street from the steps of New Hanover High School.

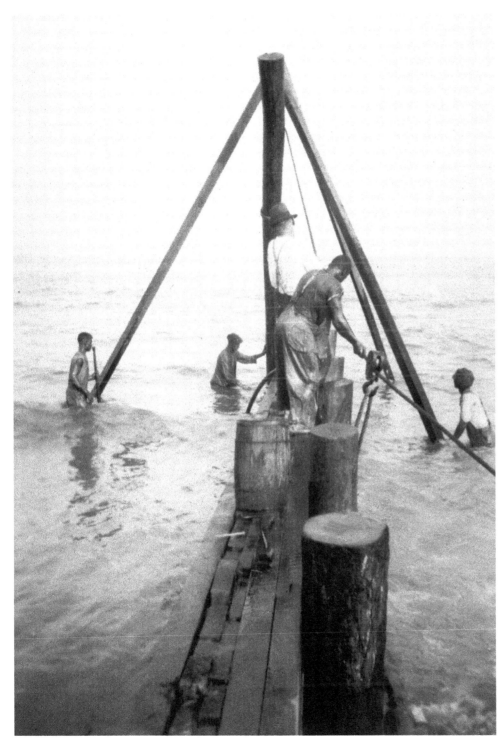

Beach erosion in the Wilmington region is nothing new (nor a problem with an end in sight). Across the years, numerous attempts have been made to curb it, including a series of wooden jetties installed at Wrightsville Beach in the 1920s—the construction in view here is under way in 1923. Such attempts have met, at best, with limited success.

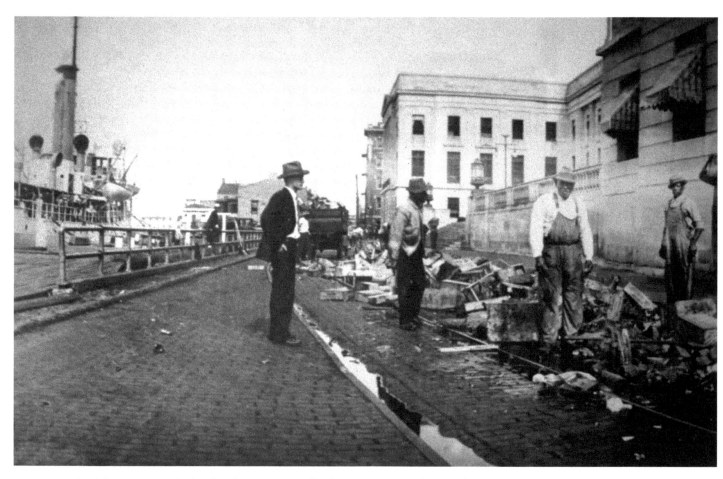

Prohibition in North Carolina began in 1909; but between 1920 and 1933, federal agencies prosecuted those who distilled and smuggled illegal liquor. As a port city teeming with waterways and beaches, Wilmington became a bootlegger's paradise. Shown here in the mid-1920s, a federal agent supervises the destruction of illicit booze near the steps of the Customs House. Alcohol seemed to reach nightspots such as the Lumina Pavilion, despite state and federal diligence.

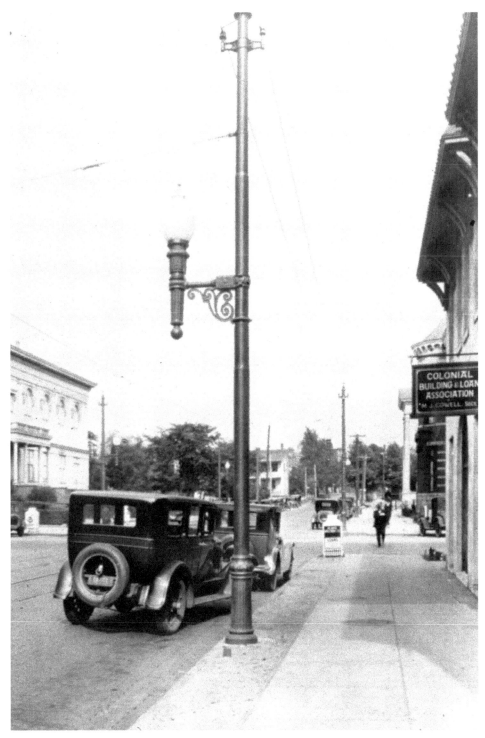

A camera captures Princess Street near Third Street around 1924. Clean, busy streets flanked by electric streetlights and even public trashcans convey an aura of prosperity to the scene. It appears that Colonial Building & Loan Association (at right) has a few customers. The easy credit of the 1920s would return to haunt borrowers (state and local governments as well as private citizens) by the end of the decade.

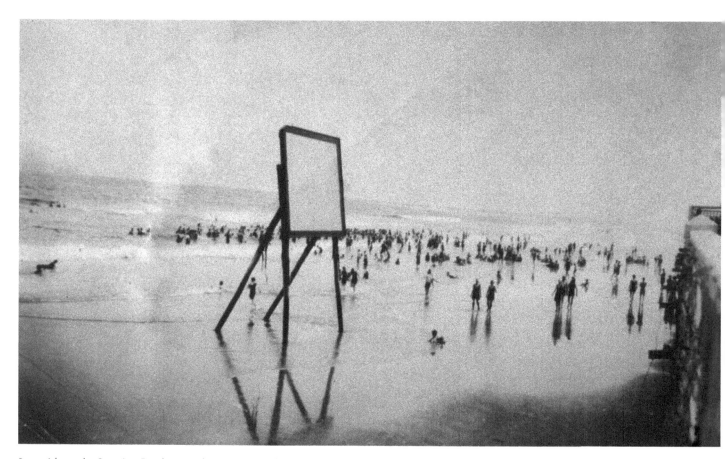

Low tide at the Lumina Pavilion in the 1920s reveals a good view of the movie screen. Lumina continued showing movies from 1913 until the advent of "talkies," which could not be heard above the roaring surf.

This image of Fourth Street, recorded in the 1920s, centers on the monument to Cornelius Harnett, representative to the Continental Congress. On the right are the rear of the Temple of Israel and the Carolina Apartments. Opposite the apartments stands the First Baptist Church.

On February 21, 1925, the cruise ship *Fort Hamilton,* registered in Bermuda, docked at Wilmington on the first of several visits in an attempt to establish a regular cruise line in the Port City.

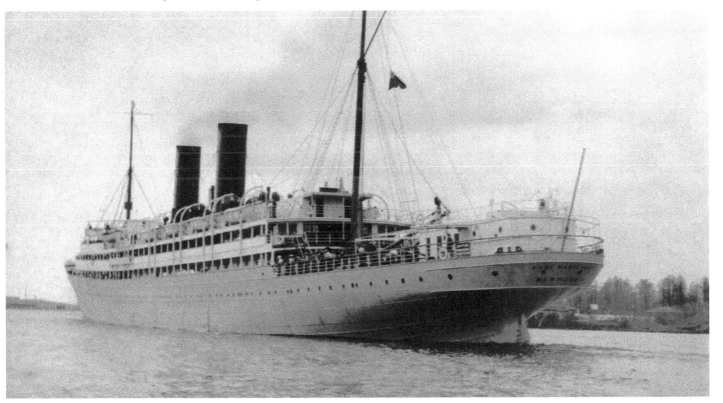

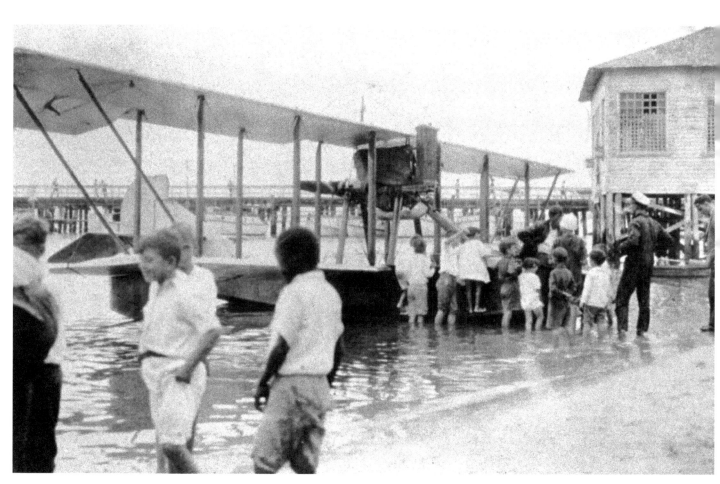

Both seaplanes and amphibious planes sometimes landed at Banks Channel, but onlookers called them "hydroplanes," regardless of type. Inevitably they drew a crowd. This landing dates to the 1920s.

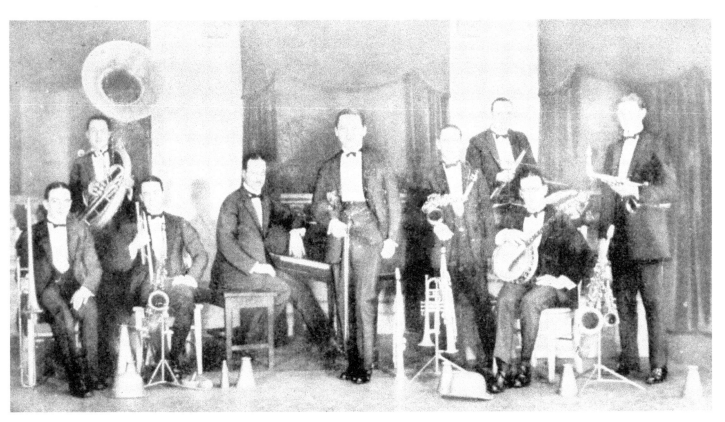

Music and dancing in the evenings were as much a part of the mystic of Lumina Pavilion as its hundreds of gleaming electric lights. Big name bands, such as the Weidmeyer Orchestra from Huntington, West Virginia, provided music throughout the summer months.

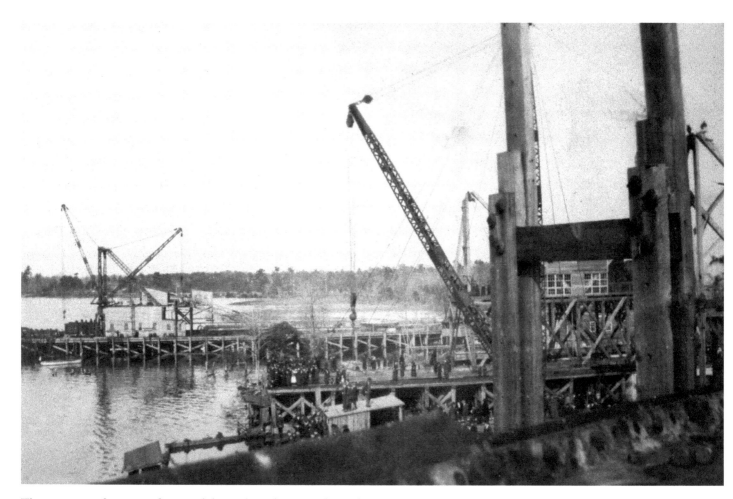

The mass manufacturing of automobiles in the early 1900s changed the American way of life in many ways. Combined with the tourism industry, which began assuming tremendous importance on the Carolina Coast in the 1920s, this introduced a desire to connect the many barrier islands and once pristine beaches. In 1925, construction began on a causeway to join Harbor Island (also known as the Hammocks) to the mainland.

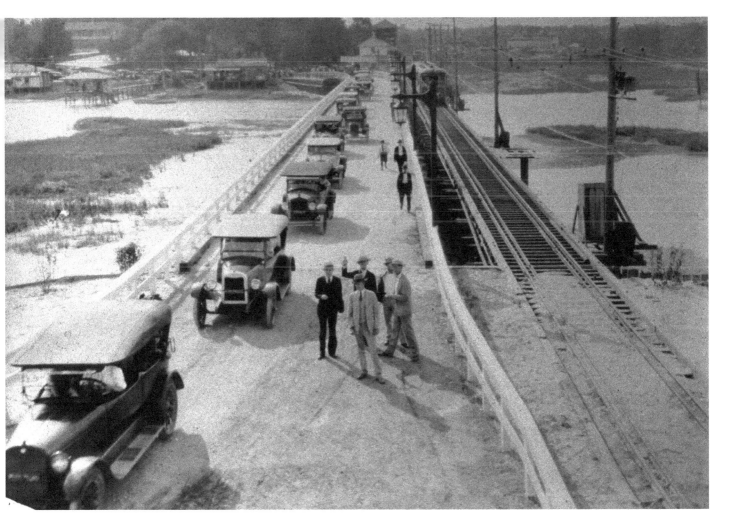

The causeway to Harbor Island, paralleling the trolley track across Wrightsville Sound, opened in 1925. A second causeway, opened in 1926, joined Wrightsville Beach to the mainland. The opening of these causeways was the beginning of the end for the old electric Beach Trolley, though few people suspected it at the time.

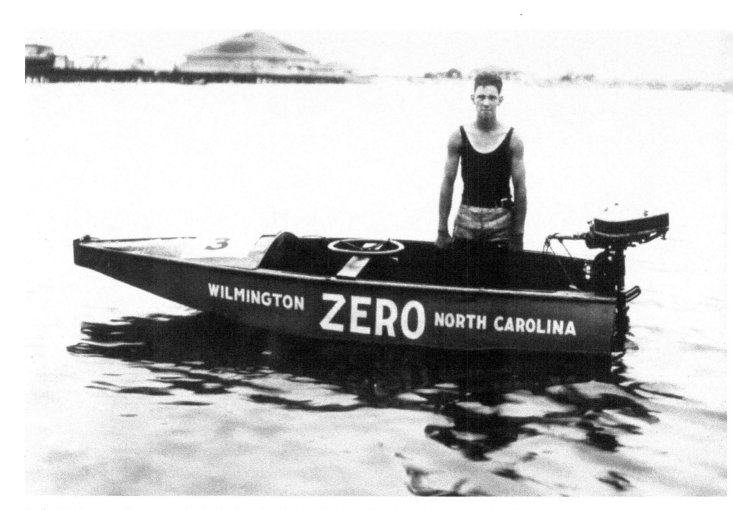

In the 1920s, motorboat racing in Banks Sound and along the Cape Fear River became popular. Gene Pickard, age 16, poses with his boat, the *Zero*.

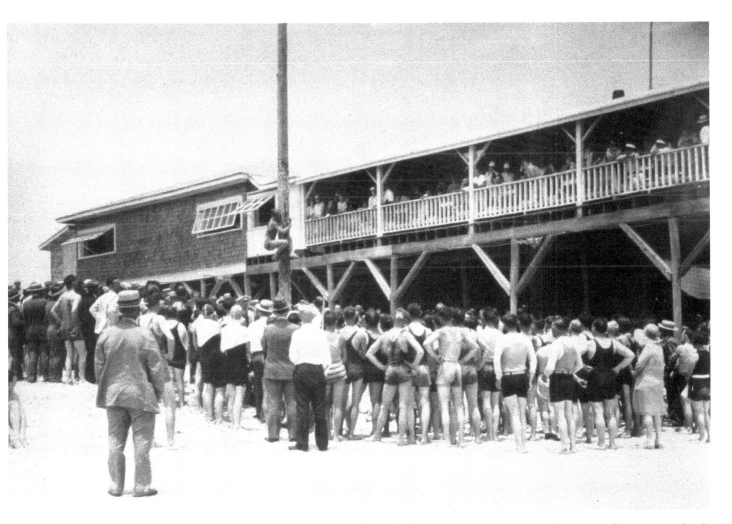

A small crowd cheers the competitors onward (or upward!) in a greased pole contest in the 1920s. Athletic competitions at Lumina drew big crowds on the Fourth of July and Labor Day.

Bathing beauty contests at Lumina, this one in 1927, attracted far more viewers than greased-pole contests!

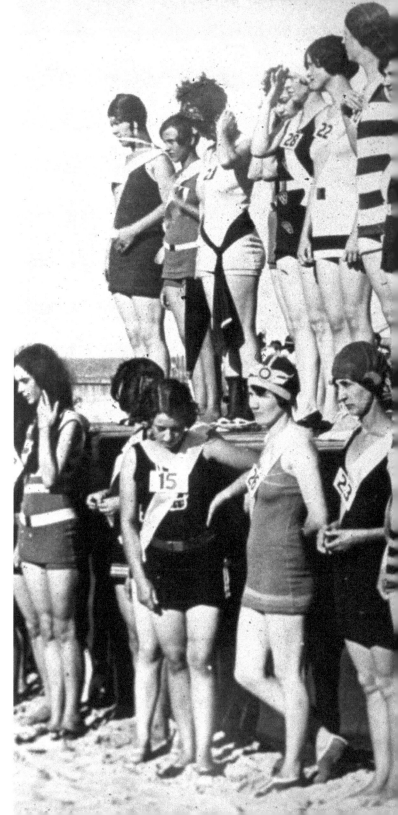

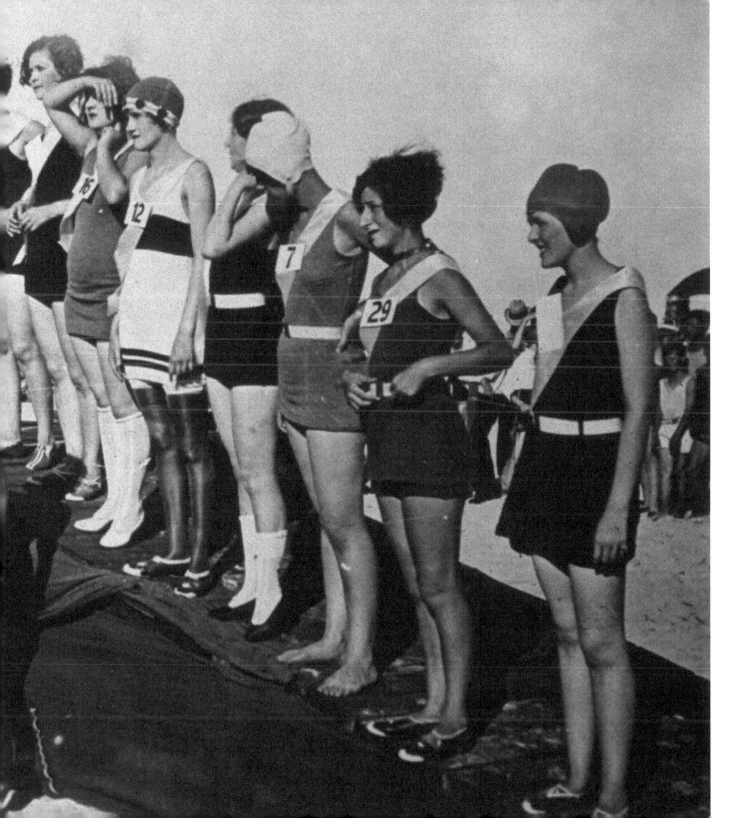

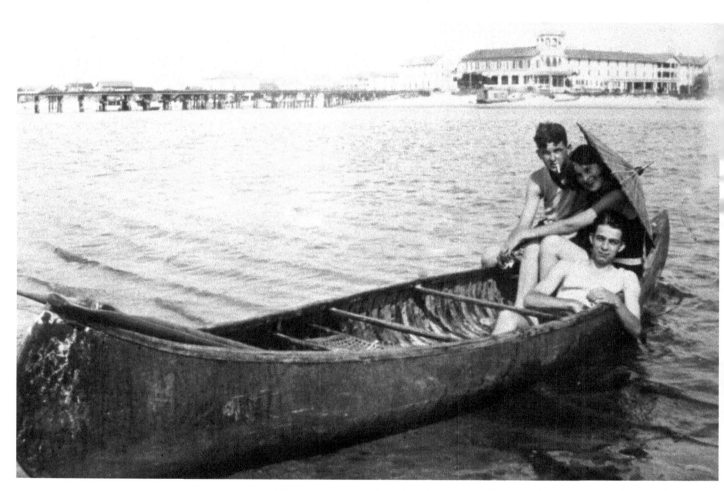

Two young men and a lady enjoy a sunny day canoeing on the sound off Harbor Island.

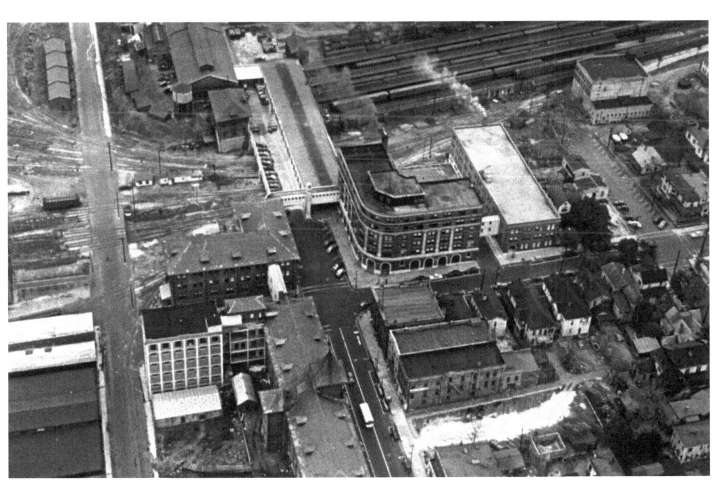

This aerial view from the late 1920s, centered on Union Station as it curves along Front and Red Cross streets, conveys the span of the Atlantic Coast Line's extensive terminal and office network in Wilmington.

By 1928, the number of surviving veterans of the Civil War in Wilmington had dwindled to a mere handful. On January 19, Confederate Veteran's Day, those survivors gathered on the porch of the YWCA on North Second Street.

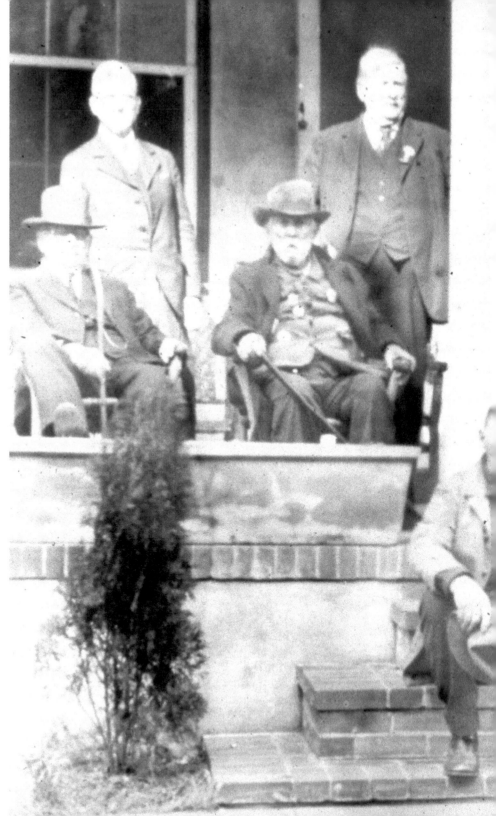

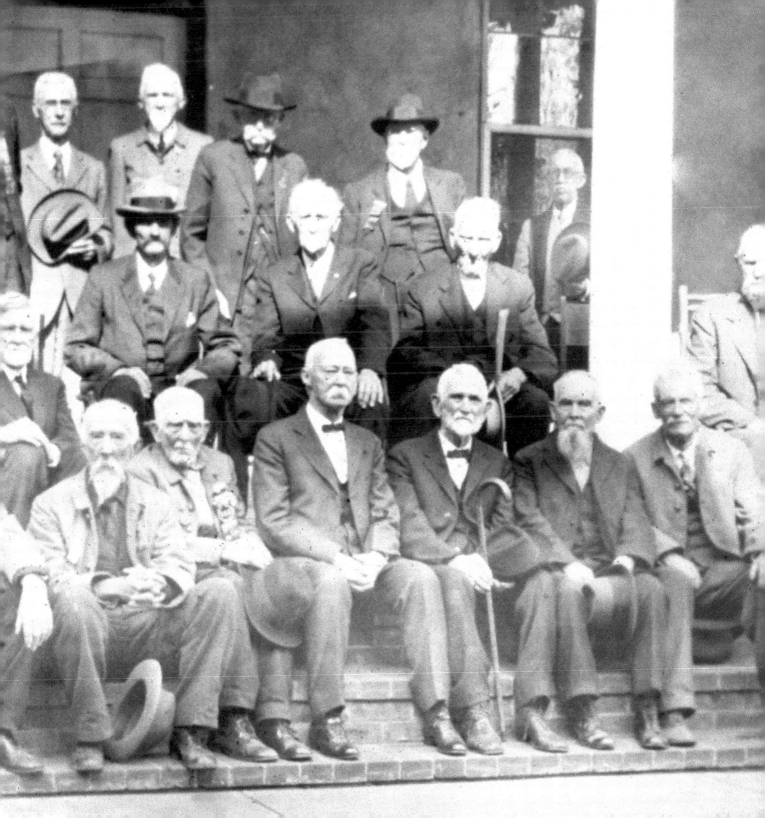

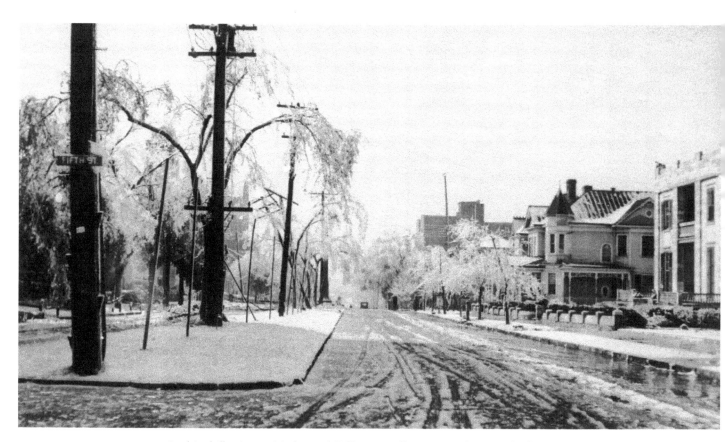

As this chilly view at Market and Fifth streets illustrates, Wilmington's pleasant average yearly temperature can be trumped by the actual temperature on any given day. The photograph shows the aftermath of snowfall and a destructive ice storm, which has severed large tree limbs and left trees and utility lines drooping.

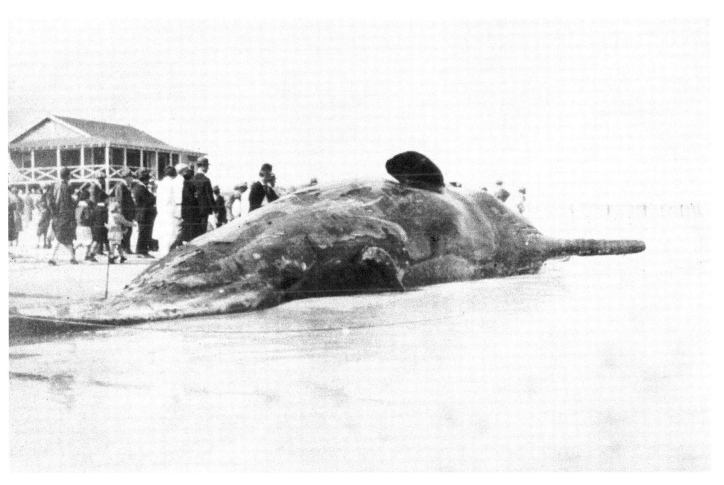

A 50-ton sperm whale washed ashore at Wrightsville Beach in 1928. Tourists flocked to see it—until the smell reached epic proportions. The remnant of the rotting carcass made its way to the North Carolina Museum of Natural History in Raleigh.

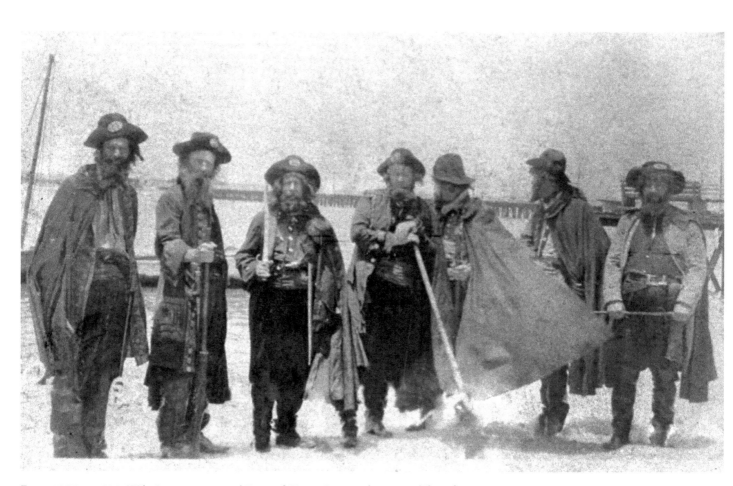

From 1927 to 1929, Wilmington sponsored Feast of Pirates Days each August. Though no one ever found the legendary treasure buried by Captain Kidd on Money Island at Greenville Sound, everyone had loads of fun—including the scurvy crew in this image. And the tourists loved the pageantry.

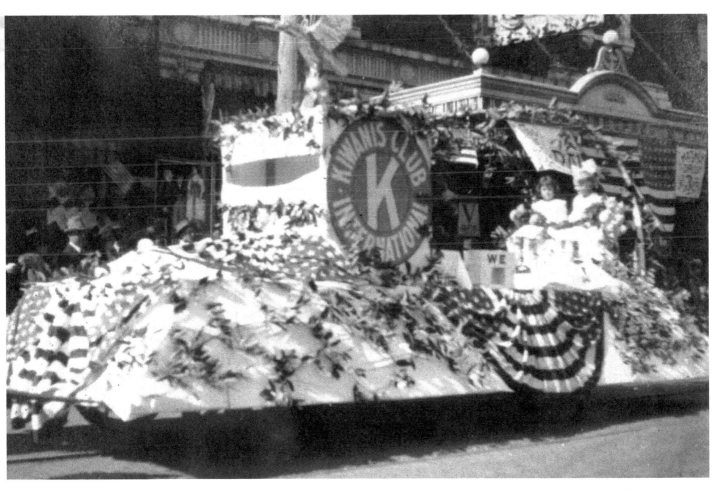

The Kiwanis Club sponsored this float in one of the annual Feast of Pirates parades.

Homes in the Port City caught the spirit of the Feast of Pirates. But these decorations on the Carpenter House on Fifth Street were put in storage for the last time in 1929. Only a few short weeks later, Wall Street's crash signaled a new period in the history of Wilmington: the Great Depression.

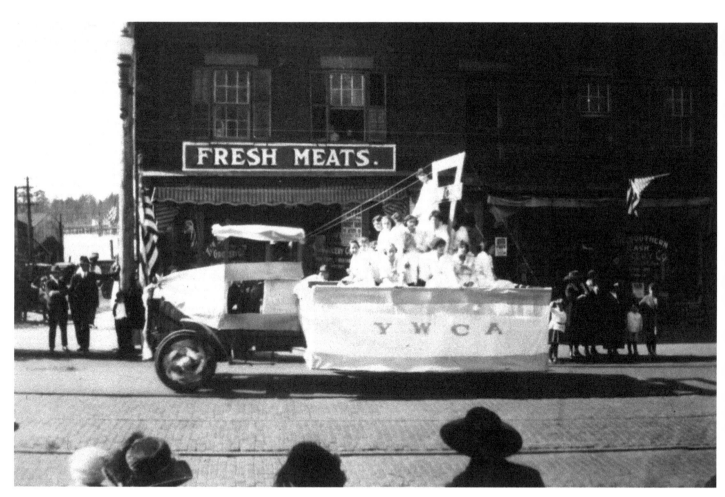

Young ladies of the YWCA participate in a Feast of Pirates parade along Front Street.

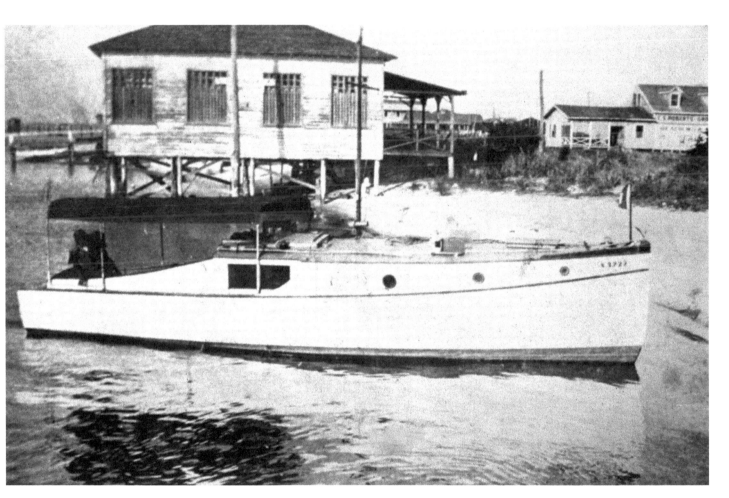

A cabin cruiser rests at its moorings in Banks Channel at Wrightsville Beach around 1929. Perhaps its owners are shopping in the building immediately behind the boat—Rogers Grocery Store.

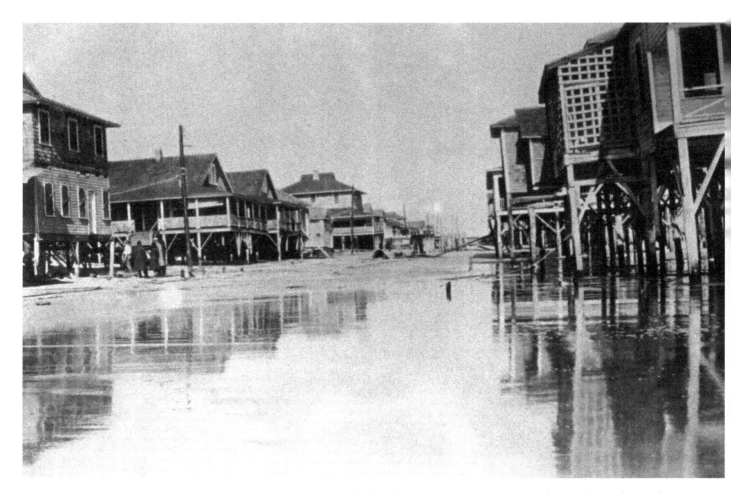

In September 1929, a storm inundated the Wilmington area. Heavy waves damaged some homes, but everyone agreed that things could have been worse. Hundreds of miles up the coast, another storm appeared, in New York City. The crash of stocks sounded far louder than the crash of thunder. By the mid-1930s, most Wilmingtonians agreed, many concluding that things could not be worse.

FOUR DECADES OF CHANGE

(1930–1970)

The Great Depression struck North Carolina less severely than many states, primarily owing to the state's lack of industry and urbanization, and the strenuous effort at state and local levels to balance the load among the people. To be sure, Wilmingtonians suffered the misery of unemployment, but the city survived those harsh years remarkably well. Its importance as a transportation node was only partly responsible for that outcome. People pulled together, spent the occasional day at the beach to keep life sunny, and the city took advantage of WPA money with urban renewal projects including the creation of Greenfield Lake and Gardens.

Only the massive employment created by World War II ended the Great Depression. In Wilmington and New Hanover County, hundreds answered the call to arms. Others supported the war industry, whether building floating drydocks for V. P. Loftis and Tidewater Construction companies, launching some of the 243 ships built by North Carolina Shipbuilding Company, or working on the waterfront itself. By VJ-Day, depression had ended and the overall future of the city looked rosy. The rose was already a West Coast city's symbol, so Wilmington grabbed the azalea. Thus began an annual Azalea Parade that remains popular to this day.

Challenges remained. The State Port Authority, created in 1945, shifted shipping to the terminal downstream of the old docks by the 1950s. Businesses that had endured for years shifted with it. The old waterfront area, already suffering from neglect, began to collapse. Frequent fires accelerated the process. The movement of businesses to strip malls and suburban shopping centers beginning in the late 1950s also contributed to the blight.

The relocation of the Atlantic Coast Line's general offices in the 1960s furthered the waterfront's demise. Well-intentioned efforts to help—urban renewal—cost the city many of its architectural treasures before local historical organizations gained enough influence in the 1970s to challenge it. On the positive side, two events paved the way for growth beyond 1970: the arrival of the USS *North Carolina* and the success of the University of North Carolina at Wilmington.

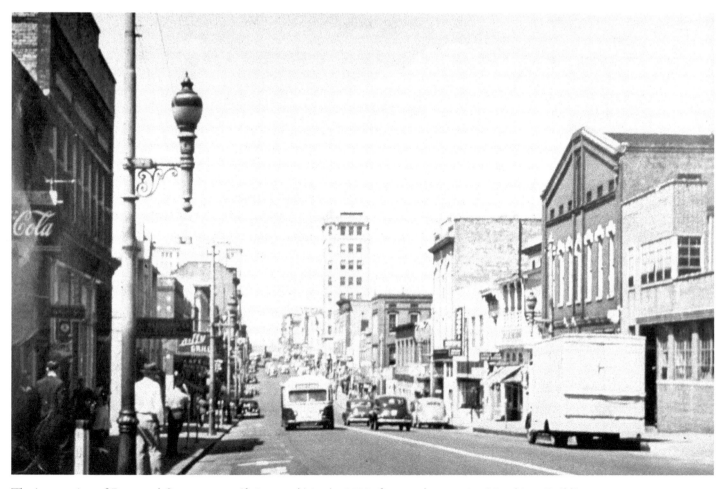

The intersection of Front and Orange streets (facing north) in the 1930s features the towering Murchison Building in the distant center. A bus traveling toward the camera signals a present and future bereft of the old electric trolleys.

The Carolina Beach Boardwalk, around 1930, became the beach of choice for the average tourist because of its growing commercial district, the myriad entertainments along its boardwalk, and especially thanks to its cheaper hotels. Tourists from afar able to afford a vacation during the Great Depression, however, were declining in number.

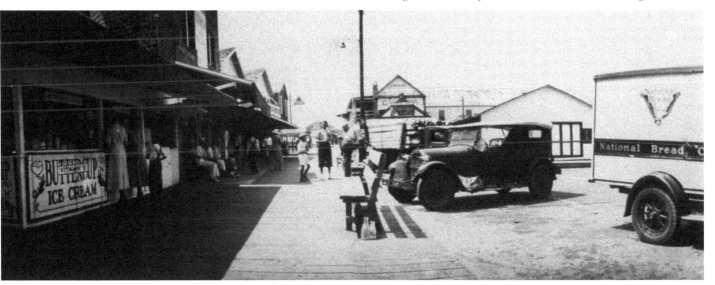

On January 28, 1934, a fire began at Kitty Cottage. Before it ended, strong winter winds swept the blaze through every structure on the northern end of Wrightsville Beach, including the majestic Oceanic Hotel.

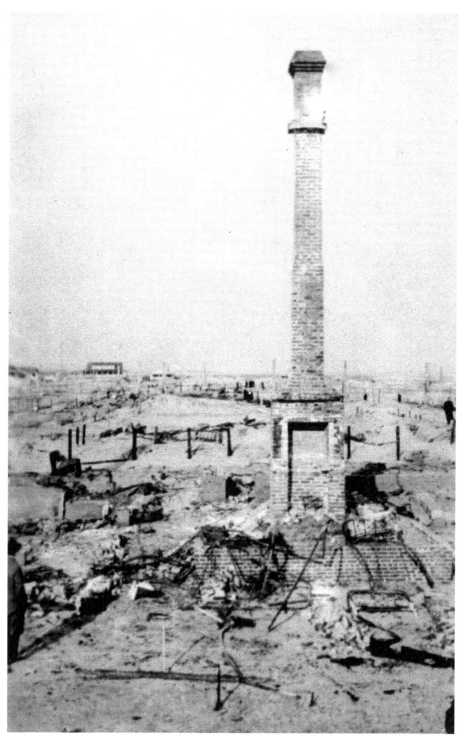

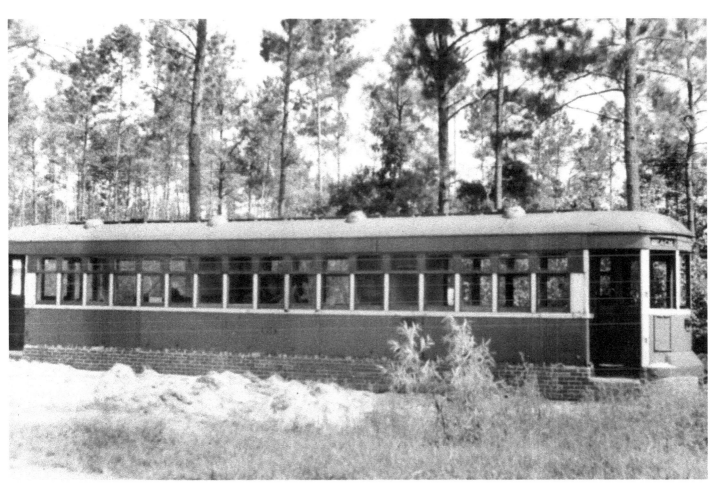

In 1939, Tide Water Power Company brought its electric trolley operations to an end. In 1925, approaching its peak, the line had operated 22 miles of track, with 9 miles double-tracked. When the trolleys stopped rolling, Wilmington lost to modernity a touch of its romance. A few Wilmingtonians refused to let the past go—after 1940, this car served for a time as a restaurant.

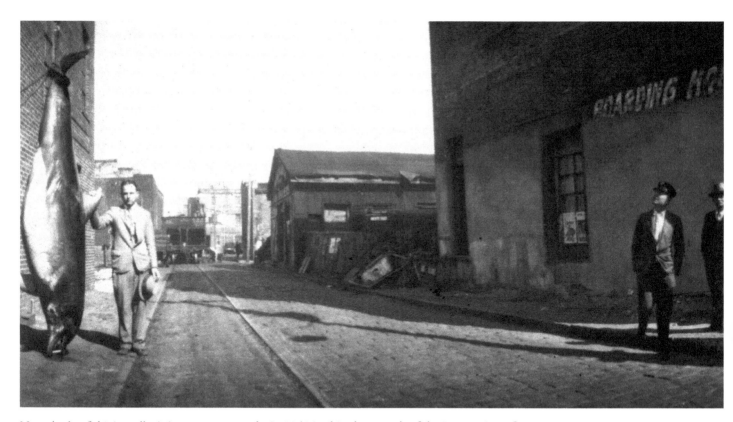

Now that's a fish! Actually, it is a sturgeon caught in 1940 in this photograph of the intersection of Muter's Alley and Water Street. The old Ice House is on the right, and it will take loads of ice to cool that impressive catch (a very uncommon catch in the Cape Fear River by the 1940s).

Gentleman Joe Palooka was playing at the Bailey Theater on Front Street in this photograph from 1940. J. C. Penney Company stands at far-right, while Western Union, at center, would see a surge in business within a year. Unfortunately, too many of those telegrams would be headed to grieving parents and spouses after the United States entered World War II.

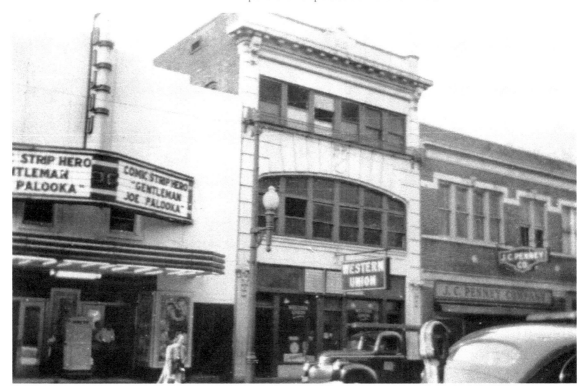

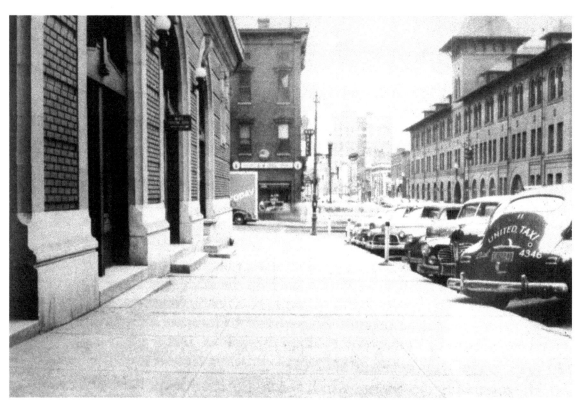

Taxis wait at Union Station on Front and Red Cross streets around 1940. Across Front Street is the old Atlantic Coast Line General Office and across Red Cross is the old Atlantic Hotel, now a retail establishment.

Students at New Hanover High School hang out between classes during the 1942-1943 school year. Each of them knows that he is only graduation and a draft notice away from the battlefield.

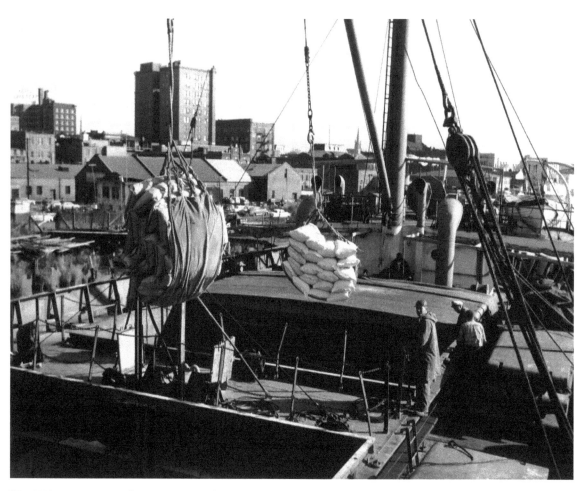

The Wilmington waterfront experienced its last great boom from 1941 to 1945, as cargo ships moved food, raw materials, and finished goods to support the Great Crusade in Europe and the Pacific. Shown here, cargo is shifted to the hold of a small merchantman. After 1941, such vessels faced German U-boats once they left the mouth of the Cape Fear River.

In 1950, Broadfoot Iron Works performed repairs on the Presidential Yacht *Sequoia* (bow at left). In the distance at right is the Wilmington skyline.

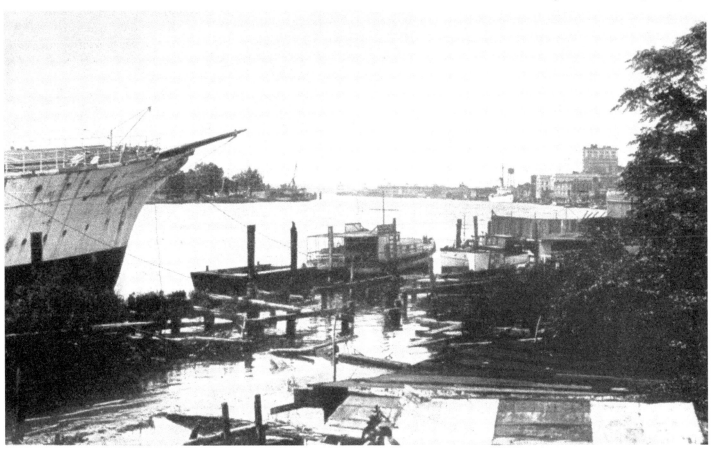

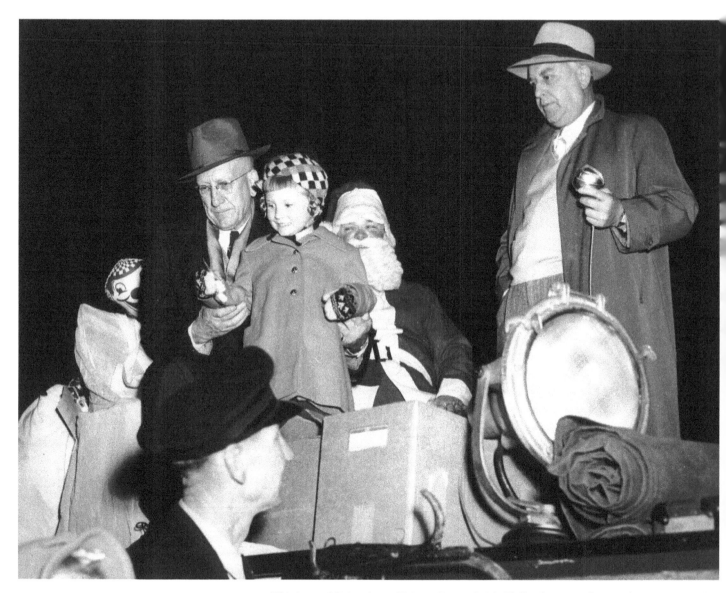

This is a publicity shot of Mayor Royce S. McClelland, snapped around 1950. Upstaging
Santa Claus had to be a nifty political coup!

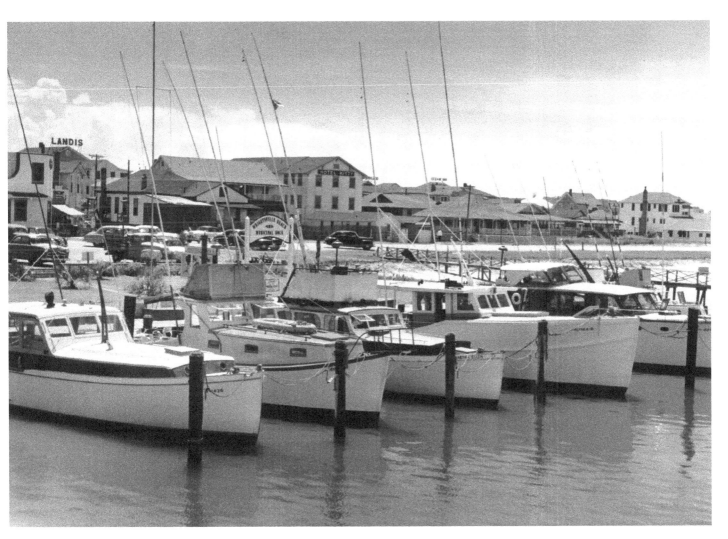

The marinas at Wrightsville Beach teemed with lovely boats in the early 1950s. In October 1954, however, Hurricane Hazel slammed ashore with 140 M.P.H. winds, leaving more than $7,000,000 of damage and numerous fatalities in North Carolina as its legacy.

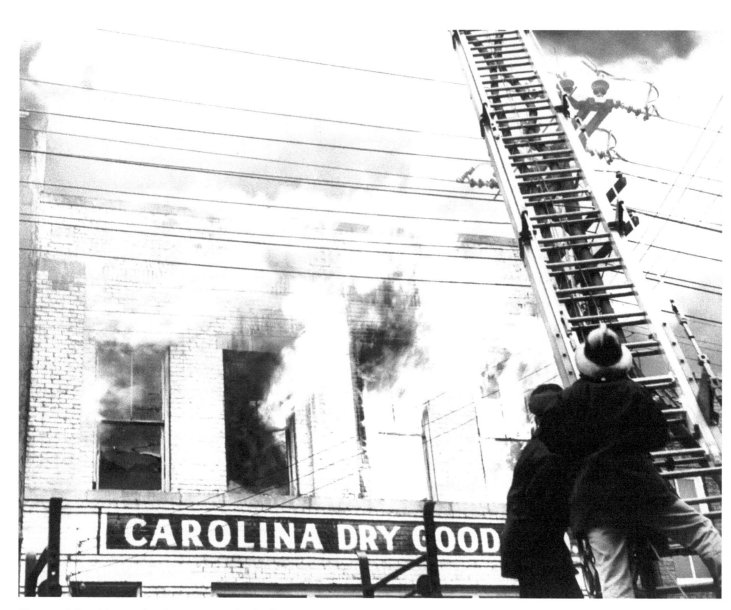

Firemen fight a blaze at Carolina Dry Goods (the former Seaman's Bethel, a chapel for seamen) in 1958. Numerous fires during the 1950s threatened Wilmington's downtown and its aging buildings. Perhaps none were so dangerous as the nitrate fire at a warehouse on the river in 1953 with its accompanying explosions.

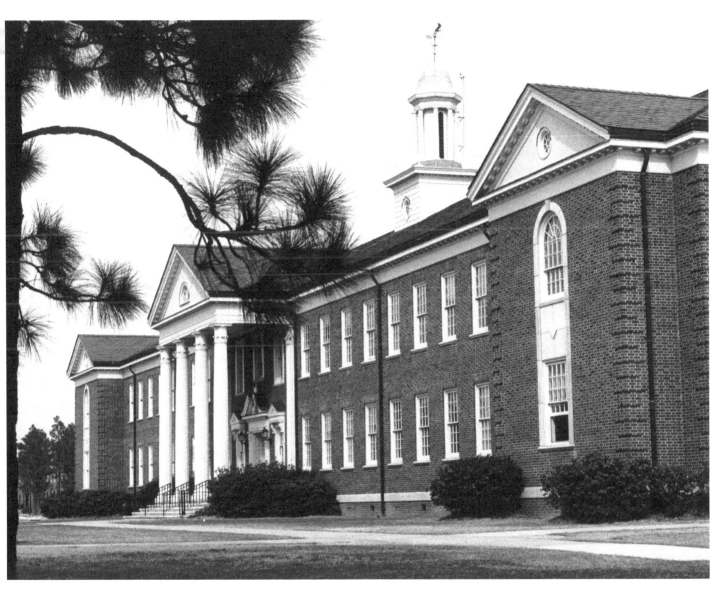

Wilmington College opened in 1947 at the old Isaac Bear School building on Market Street. In 1968, the college achieved university status as the University of North Carolina at Wilmington. Today, the College Road campus is one of the most beautiful and dynamic in North Carolina's university system. This view of Hoggard Hall dates from the 1960s.

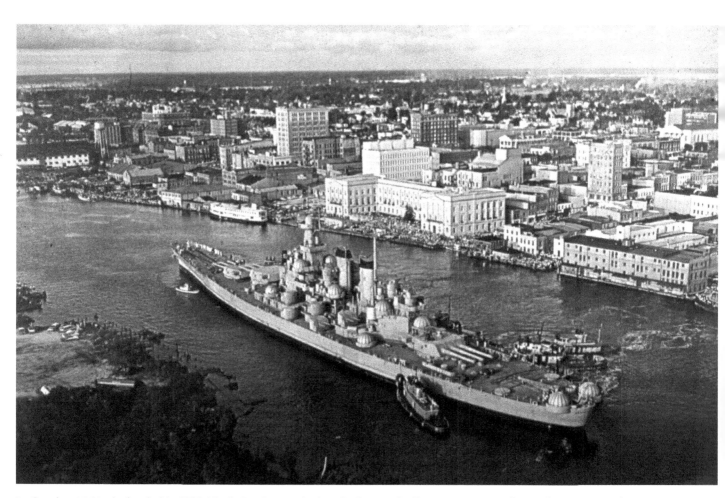

In October 1961, the battleship USS *North Carolina* reached its final port of call as a war memorial in Wilmington. Partly financed with money collected by schoolchildren, the "showboat" remains docked at Eagle Island, where its sound and light show continues to amaze and educate thousands of tourists every year.

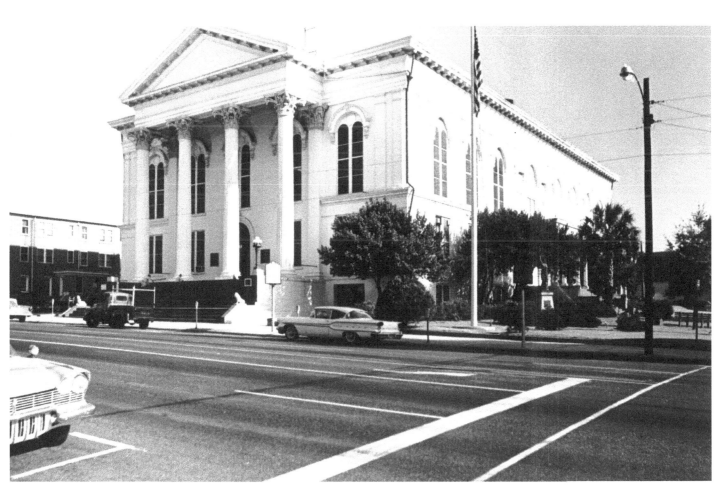

In the 1960s, well-meaning groups leveled many older buildings in the name of urban improvement. Fortunately, Wilmington's historic City Hall survived.

The heritage of Wilmington residents remains tied to water and boating. Here in the 1960s, Harriet Bellamy McDonald and friends take a small cabin cruiser to celebrate life and the pleasure of living in Wilmington.

The John A. Taylor House on Market Street, built in 1847, has served as a private home, the headquarters of the Wilmington Light Infantry, the location of the Wilmington Public Library, and has been used by First Baptist Church. This photo was snapped in the 1960s while it housed the Public Library.

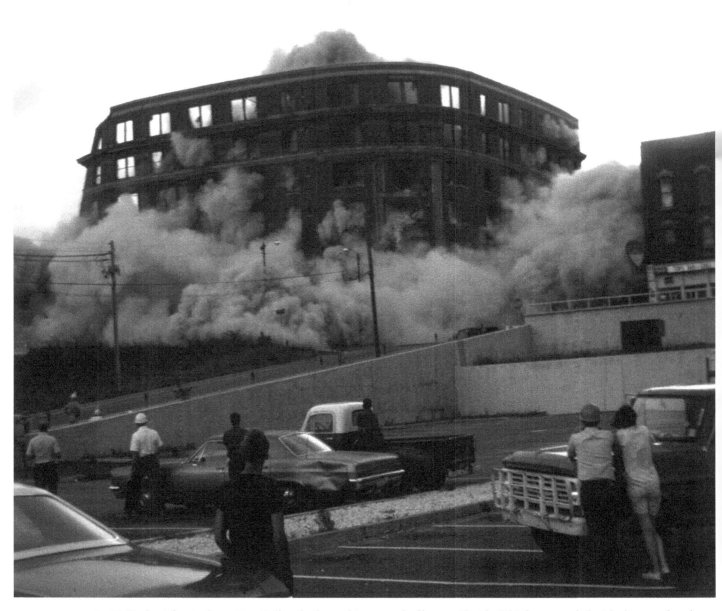

In 1960, the Atlantic Coast Line Railroad relocated its general offices to Florida. This loss, coupled with the transfer of port traffic to Port Authority's terminal downriver (ongoing after 1945), left vacant buildings to rot along the riverfront. In 1970, the city demolished the abandoned Union Station. Perhaps it gave closure to the loss of the ACL, but the dynamite also destroyed a marvelous bit of architecture. The loss of Union Station helped to light the fuse for historic preservation.

NOTES ON THE PHOTOGRAPHS

These notes, listed by page number, attempt to include all aspects known of the photographs. Each of the photographs is identified by the page number, photograph's title or description, photographer and collection, archive, and call or box number when applicable. Although every attempt was made to collect all available data, in some cases complete data was unavailable due to the age and condition of some of the photographs and records.

II CITY HALL
Lower Cape Fear Historical Society
72.374.23.a

VI ATLANTIC OFFICE
New Hanover County Public Library
Dr. Robert M. Fales Collection
441

X ST. JAMES CHURCH
Daguerreotype, sixth-plate, ca. 1847
Amon Carter Museum, Fort Worth, Texas
P1981.65.28

2 INTERIOR, FORT FISHER, 1869
New Hanover County Public Library
Dr. Robert M. Fales Collection
888

4 CONFEDERATE BLOCKADE RUNNER
New Hanover County Public Library
Dr. Robert M. Fales Collection
888

5 RAILROAD
Lower Cape Fear Historical Society
59.53.1

6 ARMSTRONG GUN AT FORT FISHER
New Hanover County Public Library
Dr. Robert M. Fales Collection
509

7 FRED HAMME, SR., 1873
New Hanover County Public Library
Dr. Robert M. Fales Collection
620

8 SECOND AND MARKET
New Hanover County Public Library
Dr. Robert M. Fales Collection
460

9 LOOKING SOUTH ON RIVER, 1880
New Hanover County Public Library
Dr. Robert M. Fales Collection
788

10 POLICE DEPARTMENT
New Hanover County Public Library
Dr. Robert M. Fales Collection
485

11 CITY MARKET HOUSE, 1881
New Hanover County Public Library
Dr. Robert M. Fales Collection
400

12 CITY-COUNTY HOSPITAL, 1881-1901
New Hanover County Public Library
Dr. Robert M. Fales Collection
55

13 EARLY WATERFRONT PRIOR TO 1892
New Hanover County Public Library
Dr. Robert M. Fales Collection
880

14 FRONT AND MARKET STREETS
New Hanover County Public Library
Dr. Robert M. Fales Collection
645

16 FRONT STREET METHODIST CHURCH
New Hanover County Public Library
Dr. Robert M. Fales Collection
956

17 BALLOON
Lower Cape Fear Historical Society
72.374,84

18 COMPRESS DOCKS
Lower Cape Fear Historical Society
58.36,10

19 NURSES AND DOCTORS
New Hanover County Public Library
Dr. Robert M. Fales Collection
21

20 FRONT ST. BETWEEN MARKET AND PRINCESS
New Hanover County Public Library
Dr. Robert M. Fales Collection
629

21 POST OFFICE, 1891
New Hanover County Public Library
Dr. Robert M. Fales Collection
585

22 FISHBLATE CLOTHING STORE
New Hanover County Public Library
Dr. Robert M. Fales Collection
1119

23 WATER STREET
New Hanover County Public
Library
Dr. Robert M. Fales Collection
1091

24 HORSE AND BUGGY
Lower Cape Fear Historical
Society
57.20,36.a

25 ST. JOHN'S EPISCOPAL
CHURCH
Lower Cape Fear Historical
Society
70.286,1.a

26 WILMINGTON HIGH SCHOOL
New Hanover County Public
Library
Dr. Robert M. Fales Collection
1107

27 TILESTON ELEMENTARY
SCHOOL
Lower Cape Fear Historical
Society
71.320,7.a

28 DOCKS OF WORTH &
WORTH
Lower Cape Fear Historical
Society
58.36,9

29 SCHOOLCHILDREN
Lower Cape Fear Historical
Society
76.433,3

30 TRAIN WRECK
Lower Cape Fear Historical
Society
72.374,94

31 WILMINGTON
WATERFRONT
Lower Cape Fear Historical
Society
57.20,9

32 RACE RIOT
New Hanover County Public
Library
Dr. Robert M. Fales Collection
891

33 VIGILANTES
New Hanover County Public
Library
Dr. Robert M. Fales Collection
602

34 DESTRUCTION OF
RAILROAD TRESTLE
New Hanover County Public
Library
Dr. Robert M. Fales Collection
680

35 HANOVER SEASIDE CLUB
New Hanover County Public
Library
Dr. Robert M. Fales Collection
1324

36 RIVER STEAMER
New Hanover County Public
Library
Dr. Robert M. Fales Collection
628

37 W. B. THORPE & CO.
New Hanover County Public
Library
Dr. Robert M. Fales Collection
877

38 BIG UNION SCHOOL ON
ANN STREET
New Hanover County Public
Library
Dr. Robert M. Fales Collection
1015

39 UNION STATION
TERMINAL
New Hanover County Public
Library
Dr. Robert M. Fales Collection
667

40 ORTON HOTEL
New Hanover County Public
Library
Dr. Robert M. Fales Collection
30

41 JOHN ANCRUM
RESIDENCE
New Hanover County Public
Library
Dr. Robert M. Fales Collection
958

42 BANK'S CHANNEL WITH
SAILBOAT
New Hanover County Public
Library
Dr. Robert M. Fales Collection
931

44 SKIFFLIKE BOAT
Lower Cape Fear Historical
Society
57.20,42

45 SOUTHSIDE PRINCESS
STREET
New Hanover County Public
Library
Dr. Robert M. Fales Collection
780

46 ST. JAMES CHURCH
New Hanover County Public
Library
Dr. Robert M. Fales Collection
29

48 MARKET AND SEVENTH
STREETS
Lower Cape Fear Historical
Society
57.20,35.b

49 THE PASSPORT
Lower Cape Fear Historical
Society
69.280,20

50 LOADING THE LIGHTER
New Hanover County Public
Library
Dr. Robert M. Fales Collection
633

52 MEAT MARKET
New Hanover County Public
Library
Dr. Robert M. Fales Collection
406

53 ALEXANDER SPRUNT AND
SONS BUSINESS OFFICE
New Hanover County Public
Library
Dr. Robert M. Fales Collection
1110

54 COUNTRY SCHOOL
New Hanover County Public
Library
Dr. Robert M. Fales Collection
681

55 PEOPLES SAVINGS BANK
New Hanover County Public
Library
Dr. Robert M. Fales Collection
781

56 SOUTH 3RD STREET
New Hanover County Public
Library
Dr. Robert M. Fales Collection
34

57 CITY HALL
New Hanover County Public
Library
Dr. Robert M. Fales Collection
26

58 HONOR GUARD
New Hanover County Public
Library
Dr. Robert M. Fales Collection
949

59 M. G. Tiencken
Variety Store
New Hanover County Public
Library
Dr. Robert M. Fales Collection
959

60 Inside View, M. G.
Tiencken Variety
Store
New Hanover County Public
Library
Dr. Robert M. Fales Collection
960

61 Women Wading at
Wrightsville Beach
New Hanover County Public
Library
Dr. Robert M. Fales Collection
1130

62 Wilmington High
School
New Hanover County Public
Library
Dr. Robert M. Fales Collection
1143

63 Auditorium of Big
Union School
New Hanover County Public
Library
Dr. Robert M. Fales Collection
1008

64 Cape Fear Club
New Hanover County Public
Library
Dr. Robert M. Fales Collection
1213

65 Hanover Seaside
Club
New Hanover County Public
Library
Dr. Robert M. Fales Collection
1325

66 Flat Ferry
New Hanover County Public
Library
Dr. Robert M. Fales Collection
3

67 General Office
New Hanover County Public
Library
Dr. Robert M. Fales Collection
545

68 Round House at ACL
Railroad Co.
New Hanover County Public
Library
Dr. Robert M. Fales Collection
675

69 ACL Railroad Building
New Hanover County Public
Library
Dr. Robert M. Fales Collection
1122

70 North Front St. and
River
New Hanover County Public
Library
Dr. Robert M. Fales Collection
373

71 View of Downtown
Wilmington
New Hanover County Public
Library
Dr. Robert M. Fales Collection
372

72 Baggage Car
New Hanover County Public
Library
Dr. Robert M. Fales Collection
498

73 Coast Guard Tower
New Hanover County Public
Library
Dr. Robert M. Fales Collection
1019

74 Original JWM
Hospital
New Hanover County Public
Library
Dr. Robert M. Fales Collection
1176

75 Shepard Pharmacy
Interior
New Hanover County Public
Library
Dr. Robert M. Fales Collection
1148

76 Hook and Ladder
Wagon, Fire Department
New Hanover County Public
Library
Dr. Robert M. Fales Collection
951

77 Inside Grocery Store
New Hanover County Public
Library
Dr. Robert M. Fales Collection
676

78 City of Wilmington
Lower Cape Fear Historical
Society
57,20.11

79 Original Bijou Theatre
New Hanover County Public
Library
Dr. Robert M. Fales Collection
826

80 Brigade Boys Club
New Hanover County Public
Library
Dr. Robert M. Fales Collection
756

81 Original Brigade
Boys Club
New Hanover County Public
Library
Dr. Robert M. Fales Collection
358

82 Front Street
Lower Cape Fear Historical
Society
57.20,30

83 Band
Lower Cape Fear Historical
Society
57.20,27

84 Andrew J. Howell
Lower Cape Fear Historical
Society
59.53,4

85 Office
New Hanover County Public
Library
Dr. Robert M. Fales Collection
448

86 Women's Ward
New Hanover County Public
Library
Dr. Robert M. Fales Collection
59

87 W. H. Taft
New Hanover County Public
Library
Dr. Robert M. Fales Collection
385

88 Motorcycles
New Hanover County Public
Library
Dr. Robert M. Fales Collection
500

90 Front and Red Cross
New Hanover County Public
Library
Dr. Robert M. Fales Collection
1157

91 Board of Aldermen
New Hanover County Public
Library
Dr. Robert M. Fales Collection
755

92 NEW HANOVER COUNTY
STEAM ENGINE
New Hanover County Public
Library
Dr. Robert M. Fales Collection
754

93 ST. MARY'S CATHOLIC
CHURCH
New Hanover County Public
Library
Dr. Robert M. Fales Collection
554

94 CAPE FEAR ACADEMY
New Hanover County Public
Library
Dr. Robert M. Fales Collection
1181

95 PARADE
Lower Cape Fear Historical
Society
64.174

96 CITY STREET CARS
New Hanover County Public
Library
Dr. Robert M. Fales Collection
497

98 SEAGATE STATION,
BEACH ELECTRIC LINE
New Hanover County Public
Library
Dr. Robert M. Fales Collection
1234

99 ESCORTS
Lower Cape Fear Historical
Society
72.374.51.d

100 TRAINED BABOON
Lower Cape Fear Historical
Society
72.374.51.c

101 RAILROAD BRIDGE
Lower Cape Fear Historical
Society
57.20,34.a

102 FRONT STREET
Lower Cape Fear Historical
Society
57.20,21

103 AIRPLANE
Lower Cape Fear Historical
Society
72.374,14

104 MRS. STEPHEN PROVOST
Lower Cape Fear Historical
Society
60.80,1

105 DEDICATION OF ISAAC
BEAR SCHOOL
New Hanover County Public
Library
Dr. Robert M. Fales Collection
1141

106 J. W. H. FUCHS
New Hanover County Public
Library
Dr. Robert M. Fales Collection
1298

107 BEACH CAR, STATION I
New Hanover County Public
Library
Dr. Robert M. Fales Collection
42

108 BALTIMORE ORIOLES
New Hanover County Public
Library
Dr. Robert M. Fales Collection
389

109 MR. DICK BURNETT
New Hanover County Public
Library
Dr. Robert M. Fales Collection
1913

110 DRUM AND BUGLE CORPS
New Hanover County Public
Library
Dr. Robert M. Fales Collection
37

111 TRAIN OF ELECTRIC
BEACH CARS
New Hanover County Public
Library
Dr. Robert M. Fales Collection
523

112 BEACH CARS AT
LUMINA
New Hanover County Public
Library
Dr. Robert M. Fales Collection
317

113 NURNBERGER MEAT
MARKET
New Hanover County Public
Library
Dr. Robert M. Fales Collection
1133

114 CHAMPIONSHIP, CITY OF
WILMINGTON BASEBALL
TEAM
New Hanover County Public
Library
Dr. Robert M. Fales Collection
264

116 WILMINGTON STREETS
Lower Cape Fear Historical
Society
72.374.27.b

117 MARKET STREET
Lower Cape Fear Historical
Society
72.374.21.a

118 HANOVER IRON WORKS
New Hanover County Public
Library
Dr. Robert M. Fales Collection
447

120 CUSTOMS HOUSE
CONSTRUCTION
New Hanover County Public
Library
Dr. Robert M. Fales Collection
256

121 DR. HERBERT
CODINGTON
New Hanover County Public
Library
Dr. Robert M. Fales Collection
67

122 FIRST BAPTIST CHURCH
New Hanover County Public
Library
Dr. Robert M. Fales Collection
678

124 NURNBERGER MEAT
MARKET
New Hanover County Public
Library
Dr. Robert M. Fales Collection
442

126 NAVAL TRAINING
STATION
New Hanover County Public
Library
Dr. Robert M. Fales Collection
502

127 FORT CASWELL
New Hanover County Public
Library
Dr. Robert M. Fales Collection
1362

128 CONSTRUCTION OF
CONCRETE SHIP
New Hanover County Public
Library
Dr. Robert M. Fales Collection
1123

129 CONCRETE SHIP
LAUNCHED
New Hanover County Public
Library
Dr. Robert M. Fales Collection
635

130 EARLY AUTOMOTIVE
AMBULANCE WITH
NURSE
New Hanover County Public
Library
Dr. Robert M. Fales Collection
970

131 NURSES AND DRIVERS
New Hanover County Public
Library
Dr. Robert M. Fales Collection
969

132 AMERICAN SOLDIERS
COMING HOME
Lower Cape Fear Historical
Society
72.374.24.a

133 OFFICERS AND
CIVILIANS
Lower Cape Fear Historical
Society
72.374.24.d

134 USCG CUTTER
SEMINOLE
Lower Cape Fear Historical
Society
72.374.75.a

135 SWIMMERS AT
GREENFIELD LAKE
New Hanover County Public
Library
Dr. Robert M. Fales Collection
639

136 WILMINGTON POLICE
DEPARTMENT
New Hanover County Public
Library
Dr. Robert M. Fales Collection
20

137 SALVAGE
New Hanover County Public
Library
Dr. Robert M. Fales Collection
855

138 THIRD AND MARKET
STREETS
New Hanover County Public
Library
Dr. Robert M. Fales Collection
769

139 FIRE
New Hanover County Public
Library
Dr. Robert M. Fales Collection
1048

140 LUMINA WITH
SWIMMERS
New Hanover County Public
Library
Dr. Robert M. Fales Collection
1239

141 BEACH
New Hanover County Public
Library
Dr. Robert M. Fales Collection
1241

142 TARRING COUNTRY
ROADS
New Hanover County Public
Library
Dr. Robert M. Fales Collection
1067

143 PARADE DAY
New Hanover County Public
Library
Dr. Robert M. Fales Collection
1037

144 MARKET STREET
New Hanover County Public
Library
Dr. Robert M. Fales Collection
1121

145 WALTER WINTER
New Hanover County Public
Library
Dr. Robert M. Fales Collection
1038

146 TIDE WATER POWER
CO. BAND
New Hanover County Public
Library
Dr. Robert M. Fales Collection
980

147 ORIGINAL BABIES
HOSPITAL
New Hanover County Public
Library
Dr. Robert M. Fales Collection
737

148 STREET SCENE
New Hanover County Public
Library
Dr. Robert M. Fales Collection
458

149 ATHLETIC CONTEST
New Hanover County Public
Library
Dr. Robert M. Fales Collection
825

150 BREAKERS HOTEL
New Hanover County Public
Library
Dr. Robert M. Fales Collection
1215

151 LARGE STING-A-REE
New Hanover County Public
Library
Dr. Robert M. Fales Collection
1030

152 RAIN FLOODWATERS
New Hanover County Public
Library
Dr. Robert M. Fales Collection
1183

153 CONSTRUCTING JETTIES
AT WRIGHTSVILLE
BEACH
New Hanover County Public
Library
Dr. Robert M. Fales Collection
1022

154 CUSTOMS HOUSE
New Hanover County Public
Library
Dr. Robert M. Fales Collection
462

155 PRINCESS STREET
New Hanover County Public
Library
Dr. Robert M. Fales Collection
320

156 LUMINA LOOKING TO
OCEAN
New Hanover County Public
Library
Dr. Robert M. Fales Collection
89

157 FOURTH STREET
Lower Cape Fear Historical
Society
72.374.22.b

158 ST. PAUL'S LUTHERAN
CHURCH
Lower Cape Fear Historical
Society
72.374.22.c

159 FORT HAMILTON
Lower Cape Fear Historical
Society
72.374.73.a

160 HYDROPLANE IN BANKS
CHANNEL
New Hanover County Public
Library
Dr. Robert M. Fales Collection
1189

161 WEIDMEYER ORCHESTRA
AT LUMINA
New Hanover County Public
Library
Dr. Robert M. Fales Collection
535

162 CONSTRUCTION OF
CAUSEWAY
New Hanover County Public
Library
Dr. Robert M. Fales Collection
1056

163 OPENING
New Hanover County Public
Library
Dr. Robert M. Fales Collection
86

164 GENE PICKARD
New Hanover County Public
Library
Dr. Robert M. Fales Collection
887

165 GREASED POLE
CONTEST
New Hanover County Public
Library
Dr. Robert M. Fales Collection
85

166 BATHING BEAUTY
CONTEST
New Hanover County Public
Library
Dr. Robert M. Fales Collection
44

168 CANOE
New Hanover County Public
Library
Dr. Robert M. Fales Collection
1186

169 AERIAL
New Hanover County Public
Library
Dr. Robert M. Fales Collection
1205

170 CONFEDERATE
VETERANS
New Hanover County Public
Library
Dr. Robert M. Fales Collection
829

172 MARKET AND FIFTH
Lower Cape Fear Historical
Society
73.374.20.a

173 WHALE
New Hanover County Public
Library
Dr. Robert M. Fales Collection
822

174 FEAST OF PIRATES
New Hanover County Public
Library
Dr. Robert M. Fales Collection
1196

175 KIWANIS FLOAT
New Hanover County Public
Library
Dr. Robert M. Fales Collection
875

176 HOUSE DECORATION
New Hanover County Public
Library
Dr. Robert M. Fales Collection
743

178 YWCA FLOAT
New Hanover County Public
Library
Dr. Robert M. Fales Collection
1026

179 WRIGHTSVILLE BEACH
New Hanover County Public
Library
Dr. Robert M. Fales Collection
1194

180 AFTER STORM
New Hanover County Public
Library
Dr. Robert M. Fales Collection
1194

182 FRONT AND ORANGE
New Hanover County Public
Library
Dr. Robert M. Fales Collection
568

183 CAROLINA BEACH
BOARDWALK
New Hanover County Public
Library
Dr. Robert M. Fales Collection
638

184 AFTER FIRE
New Hanover County Public
Library
Dr. Robert M. Fales Collection
427

185 OLD BEACH CAR
New Hanover County Public
Library
Dr. Robert M. Fales Collection
1305

186 MUTER'S ALLEY
New Hanover County Public
Library
Dr. Robert M. Fales Collection
1308

187 BAILEY THEATER
Lower Cape Fear Historical
Society
85.543,1

188 UNION STATION FOR
PASSENGERS
New Hanover County Public
Library
Dr. Robert M. Fales Collection
652

189 STUDENTS
Lower Cape Fear Historical
Society
04.875,g

190 LOADING CARGO
Lower Cape Fear Historical
Society
50.51

191 CAPE FEAR RIVER
New Hanover County Public
Library
Dr. Robert M. Fales Collection
1316

192 ROYCE S. McCLELLAND
New Hanover County Public
Library
Dr. Robert M. Fales Collection
86.582.2.a

193 WRIGHTSVILLE BEACH
Lower Cape Fear Historical
Society
50.17,a

194 FIREMEN FIGHTING
Lower Cape Fear Historical
Society
50.14

195 UNIVERSITY OF NORTH
CAROLINA
Lower Cape Fear Historical
Society
50.27,1

196 USS NORTH CAROLINA
New Hanover County Public
Library
Dr. Robert M. Fales Collection
0957

197 CITY HALL
Lower Cape Fear Historical
Society
69.258.24.a

198 HARRIET BELLAMY
McDONALD
Lower Cape Fear Historical
Society
89.650.7.c

199 JOHN A. TAYLOR
Lower Cape Fear Historical
Society
69.258.26.a

200 DEMOLITION
Lower Cape Fear Historical
Society
1320

HISTORIC PHOTOS OF WILMINGTON

For a century after its incorporation in 1740, Wilmington, North Carolina, remained a sleepy port city. The coming of the age of steam, however, especially the railroad and steamships, kindled steady growth in the city. The South's blockade runners during the Civil War, and the shipbuilding born of the World Wars of the twentieth century, fueled that growth. With expansion, of course, came growing pains.

The story of Wilmington is a story of rivers, sounds, and sea, and of a city that rose where those waters mingled. It is the story of a port that became the "Lifeline of the Confederacy" as well as the lifeline of a state. And in *Historic Photos of Wilmington,* it is the story of more than one hundred years of history told through nearly two hundred photographs—a visual record of people, places, and events, many now lost.

Born and bred a Tar Heel, Wade G. Dudley has a Ph.D. in history from the University of Alabama, and M.A. in maritime history and nautical archaeology from East Carolina University. He teaches North Carolina history, among other courses, at East Carolina University in Greenville. Dudley is the author of *Historic Photos of Winston-Salem* (Turner Publishing, 2008), *Drake: For God, Queen, and Plunder* (Potomac Books, 2003), and the award-winning *Splintering the Wooden Wall: The British Blockade of the United States, 1812-1815* (Naval Institute Press, 2003), as well as numerous articles, essays, and short stories.

Printed in the USA
CPSIA information can be obtained
at www.ICGtesting.com
JSHW071431030724
65832JS00007B/35